IMAGES
of America

GRANADA HILLS

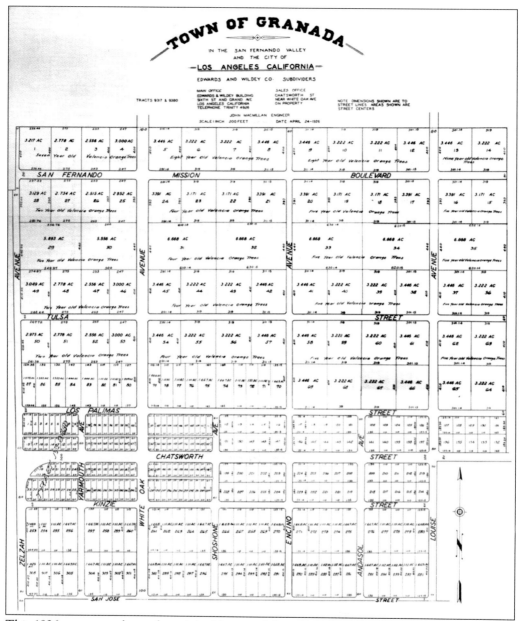

This 1926 tract map shows the original layout of the town of Granada (later renamed Granada Hills) by the noted Los Angeles developers Godfrey Edwards and Otto Wildey. Also shown are the types and ages of the various citrus trees found within a particular tract. It is interesting to note the original names of Los Alimos Street (Los Palimas) and Kingsbury Street (Kinzie). (Courtesy Granada Hills Chamber of Commerce.)

ON THE COVER: Baseball has always been a favorite pastime for residents of Granada Hills, and the chamber of commerce team was a perennial favorite in the West Valley League. This is the 1948 team. (Courtesy Robert Bates.)

IMAGES
of America

GRANADA HILLS

Jim Hier

ARCADIA
PUBLISHING

Published by Arcadia Publishing
Charleston SC, Chicago IL, Portsmouth NH, San Francisco CA

Printed in the United States of America

Library of Congress Catalog Card Number: 2007923008

For all general information contact Arcadia Publishing at:
Telephone 843-853-2070
Fax 843-853-0044
E-mail sales@arcadiapublishing.com
For customer service and orders:
Toll-Free 1-888-313-2665

Visit us on the Internet at www.arcadiapublishing.com

Granada Hills, founded in 1926, is located in the northern San Fernando Valley of Southern California. This book is intended to provide readers with a glimpse into Granada Hills' colorful history and a better understanding why it is known as "The Valley's Most Neighborly Town." (Courtesy Granada Hills Chamber of Commerce.)

CONTENTS

ACKNOWLEDGMENTS

Thomas Wolfe famously wrote, "You can't go home again," but he never said you could not go back and visit every once in awhile. That is what this book is intended to be—a visit to Granada Hills through the decades.

In most of the literature published on the history of the San Fernando Valley, rarely is anything mentioned about my hometown, Granada Hills. For this reason, and with the encouragement of friends and family, I decided to write this book.

But where to find the range of different images needed to tell the story of Granada Hills? I anticipated I could get help from some of my old Granada Hills friends. What I didn't expect was that places I had hoped would have a significant amount of material really did not. Many had lost their archives in the earthquakes or in other accidents. In some cases, families not able to keep everything simply threw material away not thinking it might have interest to others.

Thankfully, there is a reason Granada Hills is called "The Valley's Most Neighborly Town." This book is the result of the neighborly spirit of more than 100 current and former Granada Hills residents and institutions willing to open their photo albums and scrapbooks or to dig into long-hidden boxes of memorabilia. For every image in this book, at least three or four more could have easily been used.

There is not sufficient room to acknowledge everyone who helped with this book. Their names are found alongside the images they shared. I will be forever grateful for the help provided and the memories shared. Of all those who lent a hand, however, this effort would have been impossible without the assistance of two particular individuals—Jim Summers and Ken Morris.

I also thank my wife, Renette, and my daughters Caitlin and Olivia for their love and support over the several months it took to complete this effort.

Finally, this book is dedicated to the memory of my father, Ed Hier, who instilled in me a lifelong interest in history; and my mother, Ann Hier, who, along with Dad, gave my siblings and me the opportunity to call Granada Hills our hometown.

INTRODUCTION

Early Spanish missionaries called the rolling foothills northwest of the San Fernando Mission "La Encantada Cuestas," the Enchanted Hills. It would take nearly 150 years before this area would become known by another name—Granada Hills.

Located in the northern San Fernando Valley, Granada Hills is actually part of the City of Los Angeles. Over the years, the "borders" of Granada Hills have stretched as far as Tampa Boulevard (west), Lassen Street (south), Sepulveda Boulevard (east), and San Fernando Road (north). Today the town's boundaries are generally considered Aliso Canyon (just west of Zelzah Avenue), Devonshire Boulevard (south), the 405 Freeway (east), and San Fernando Road (north).

The history of Granada Hills mirrors that of the San Fernando Valley. The earliest residents were Fernandeño/Tataviam, Tongva, and Chumash Indians, estimated to have arrived in the area some 2,000 years before the Europeans.

The Spanish explorer Gaspar de Portola discovered the San Fernando Valley in 1769. On September 8, 1797, Franciscan missionaries founded San Fernando Mission Rey de España, the 17th of 21 missions eventually established in California by the Catholic Church. Present-day Granada Hills is built on former mission land, due west of the mission.

Following Mexico's independence from Spain in 1822, the mission was secularized in 1834. In December 1845, Gov. Pio Pico, the last Mexican governor of California, granted his brother Andres Pico a nine-year lease on most of the land that today comprises the San Fernando Valley. After the United States declared war against Mexico in 1846, Governor Pico sold most of the former mission land to Eulógio de Célis, in an effort to raise money to organize an army and defend California. As part of the sale of Rancho Ex-Mission San Fernando (as it was then known), de Célis agreed to continue Andres Pico's lease and his ability to live on the old mission grounds.

Following the end of the war, Andres Pico returned to the old mission, where he resumed duties as the overseer of de Célis's ranch (his brother Gov. Pio Pico fled to Mexico in August 1846). In 1874, the heirs of Eulógio de Célis sold the remaining Rancho Ex-Mission San Fernando lands, which comprised most of the northern San Fernando Valley, to Charles Maclay and cousins Benjamin F. Porter and George K. Porter. With this sale, the area known as Granada Hills began to take shape.

The Porters owned the area west of present-day Sepulveda Boulevard, and Maclay the land east of Sepulveda Boulevard, including the old mission and the area that today encompasses the City of San Fernando and Pacoima. Maclay was interested in subdividing his property and developing a new town, while the Porters focused on agriculture. In 1881, the Porters decided to divide their land to pursue different interests. The split was decided with a coin toss. George Porter won and opted for the area lying between present-day Sepulveda Boulevard and Aliso Canyon, and Roscoe Boulevard to the south. Granada Hills was becoming more defined.

George Porter established the Porter Land and Water Company and developed extensive irrigation systems on a portion of his land. He began experimenting with growing a variety of different citrus, including oranges, lemons, and grapefruit. In 1903, a series of controversial

events involving the Porter Land and Water Company began to unfold and have become a part of the history of power and privilege in the 20th century development of Southern California. On October 13, 1903, Leslie C. Brand, the "father" of Glendale, California, secured a three-year option to purchase the 16,000 acres of the Porter Land and Water Company for $560,000—$35 an acre.

In 1904, former Los Angeles mayor Fred Eaton and Department of Water and Power superintendent William Mulholland advocated bringing water from California's Owens Valley to Southern California. In the fall of 1904, Los Angeles city officials agreed to move forward with what became known as the Los Angeles Aqueduct.

The approval was supposed to be confidential, but within a week, Brand and nine others, including Porter, formed a land syndicate to purchase the Porter land. On December 3, 1904, the syndicate formally incorporated as the San Fernando Mission Land Company.

As word of the Owens Valley deal spread, land prices soared. The land, now owned by the San Fernando Mission Land Company, went from $35 an acre to as much as $4,000 an acre. It is estimated the syndicate made a profit of more than $5.5 million.

On November 5, 1913, a triumphant William Mulholland stood before a crowd of 30,000 to 40,000 Los Angelenos and famously declared, "There it is. Take it," as the valves were opened to allow water from the Owens Valley to flow into the newly constructed San Fernando Reservoir. The backdrop for this momentous event was the Cascades, the Southern California terminus of the Los Angeles Aqueduct. While technically located in Sylmar, the Cascades are a well-recognized landmark and clearly visible from the northern area of Granada Hills.

With a seemingly unlimited supply of freshwater now available, a new chapter in the history of Granada Hills was about to begin.

In 1917, Martin Henry Mosier, a wealthy Oklahoma oilman, purchased 4,100 acres of land from the San Fernando Mission Land Company. Mosier named the area Sunshine Ranch. He planted some 1,200 acres of citrus, apricots, walnuts, beans, and alfalfa. In addition to agricultural crops, a large dairy and poultry operation was built.

The center of operations for Sunshine Ranch was located near the present-day intersection of Rinaldi Street and Shoshone Avenue. The ranch consisted of 35 different buildings all painted the color of sunshine—a bright orange-yellow. While most of the buildings have disappeared, three of the original bunkhouses are still visible on Shoshone Avenue, just north of Rinaldi Street. In its time, Sunshine Ranch was considered one of the largest citrus and ranch operations in the United States.

There are two living reminders of the Sunshine Ranch still present in Granada Hills today—the beautiful deodar cedar trees that line either side of White Oak Avenue from San Jose Street, north to San Fernando Mission Boulevard, and the eucalyptus trees on the south side of each of Granada's main east and west streets.

Immediately to the east of the Sunshine Ranch was another large ranch and nursery operation. The Cascade Ranch, named after the Los Angeles Aqueduct terminus to the north, was owned by Charles C. Reynolds, former partner in Harper, Reynolds, and Company, one of Southern California's leading hardware businesses. The former land of Cascade Ranch forms much of the eastern half of Granada Hills.

In 1925, ownership of the 4100-acre Sunshine Ranch was sold to Suburban Estates, Inc.; a holding company organized by Edwards and Wildey Company, prominent Los Angeles area developers. The new enterprise, initially called the Sunshine Ranch Community Development Project, promised to spend $10 million in land and infrastructure improvements, including improved streets, sidewalks, water, gas, and electricity.

Edwards and Wildey's first priority was to name their new development. To generate interest, they sponsored a contest to name the new town. On April 18, 1926, at a celebration featuring a free Spanish barbecue, the winning name was announced—Granada. It is said the name was selected because of the physical and climatic similarity to Granada, Spain. The town of Granada was now taking shape.

Property sales in Granada were slow. To generate more interest, Edwards and Wildey began to promote Granada as an ideal place to raise rabbits and poultry, in addition to citrus fruits. Many of the houses built during this time had rabbitries built into the backyard. By the start of the Great Depression in 1929, interest in Granada had waned. Raising rabbits was not as profitable as hoped and Granada was simply too far for people who worked in Los Angeles. Suburban Estates went into receivership in 1932 and was taken over by the California Trust Company.

Granada continued to eke along through the 1930s and throughout World War II. By 1942, confident the community was here to stay, the United States Post Office requested that the town change its name to avoid confusion with the Northern California town of Grenada. The decision was made to change the name to Granada Hills.

The end of the war in 1945 and the return of war weary veterans brought a renewed interest in Granada Hills. With help from the GI Bill, many vets began graduating from college in 1949 and 1950 and were looking for a place to call home and raise their families. Also during this time, a former employee of Edwards and Wildey, Thurlow S. Culley, became instrumental in organizing and building many of the institutions that helped define the community—Granada Hills' first church, the first newspaper, and the Rotary Club to name just a few. If Granada Hills has a "Founding Father," he would be Thurlow Culley.

By the end of 1950, the population of Granada Hills stood at around 5,000. New neighborhoods were planned and built. Because of the infrastructure Edwards and Wildey had put into place, Granada Hills was better prepared than many Southern California communities for the growth to come, thanks to the postwar baby boom.

The orange and lemon groves of the Sunshine, Cascade, and other ranches gave way to new tracts of homes, shopping centers, and churches. New roads were built and old ones finally paved. New schools—five elementary schools, two junior highs, and one high school—were constructed in the span of 10 years! A private country club and golf course was opened in the shadow of Mulholland's Cascades.

Edwards and Wildey would have been pleased. The population of Granada Hills was growing like rabbits! At the end of the decade, the population increased by 1,000 percent, one of the highest 10-year growth rates in the nation, and the community was just getting started!

Identifying itself as "The Valley's Most Neighborly Town," Granada Hills continued to grow through the 1960s. New businesses and shopping centers continued to sprout up. A new public library and park were built. Houses continued to be built, including a tract of ultramodern homes by Joseph Eichler in the area known as Balboa Highlands. The San Diego Freeway was completed, providing faster and easier access for people traveling to and from Granada Hills.

Three more schools—two elementary schools and a junior high—were opened during the 1960s. A much-needed new high school was also under construction. During the 1970–1971 school year, Granada Hills High School had one of the highest school populations in the nation and the largest west of the Mississippi River.

Youth sports programs often help define a community, and Granada Hills was no different. In 1963, the Granada Hills Little League team surprised the country by winning the Little League World Series. Their victory, the first ever such game broadcast on ABC's *Wide World of Sports*, brought national attention to the team and to Granada Hills. In 1971, out of the glare of spotlights and headlines, something perhaps even more profound than the Little League World Series victory occurred—an AYSO-sanctioned all girls' soccer team played at Petit Park (now Granada Hills Park), the first in the nation.

As the 1960s ended, the 1970s began with a shock—literally. At 6:01 a.m. on February 9, 1971, residents across Southern California were jolted awake with a violent 6.6-magnitude earthquake. The quake killed 65 people and caused more than a half billion dollars in damages.

Granada Hills saw significant damage, but things could have been much worse. The earthquake crumbled a section of the Van Norman Dam's lower southern edge. Fearing the dam could break and flood the San Fernando Valley with six billion gallons of water, nearly 80,000 people were evacuated, including virtually the entire eastern half of Granada Hills. After the damage was

assessed and nerves calmed, life in Granada Hills quickly returned to normal. In September 1971, the new John F. Kennedy High School opened, immediately alleviating the overcrowding at Granada Hills High School.

Throughout the 1970s, home building continued, primarily north of Rinaldi Street, and the population continued to grow. By the end of the decade, plans were being prepared to improve the 672-acre O'Melveny Park, found at the northern end of Granada Hills. O'Melveny is the second largest park in Los Angeles after Griffith Park.

In the early 1980s, work on the controversial Simi Valley Freeway (now the Ronald Reagan Freeway), which bisects Granada Hills, was completed. The annual holiday parade, a popular community tradition, started in 1984. Long a favorite place to live for many working in the entertainment community, Granada Hills also proved a popular location for many movie and television shows in the 1980s, including *ET: the Extra-Terrestrial* and the neighborhood setting for *Knott's Landing.*

On January 17, 1994, residents of Granada Hills were again shaken from their beds by the 6.0-magnitude Northridge earthquake. Many of the more memorable images of that terrible day were found within the borders of Granada Hills. After the dust settled and the community started to rebuild, residents began to focus on issues such as rising home prices, community livability, secession from the City of Los Angeles, the possible dangers posed by the Sunshine Canyon Landfill, and preservation of Granada Hills' history.

These efforts continued as Granada Hills entered its eighth decade as a community. In 2003, Granada Hills High School became the nation's largest charter high school. Two neighborhood councils, the Granada Hills South Neighborhood Council and the Granada Hills North Neighborhood Council, were formed to channel community concerns to Los Angeles City officials, as well as state and federal government representatives. The Old Granada Hills Residents Group was formed to help protect, preserve, and improve the quality of life within the original neighborhood established by Edwards and Wildey.

In 1926, Edwards and Wildey called their new community "A City of Destiny." In the years that followed, Granada Hills and its citizens helped make that prediction come true. It is my hope this book helps tell the story of "The Valley's Most Neighborly Town."

One

THE ENCHANTED HILLS
1797–1903

On September 8, 1797, Franciscan missionaries founded San Fernando Mission Rey de España, the 17th of 21 missions eventually established by the Catholic Church. The mission and its more than 120,000 acres encompassed most of the San Fernando Valley. Early missionaries called the rolling foothills northwest of the San Fernando Mission "La Encantada Cuestas," the Enchanted Hills. Today this area is known as Granada Hills. (Courtesy San Fernando Mission Archives.)

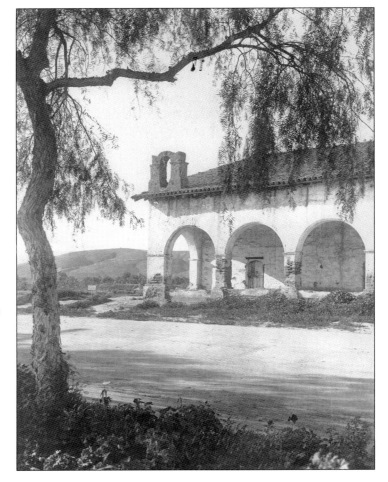

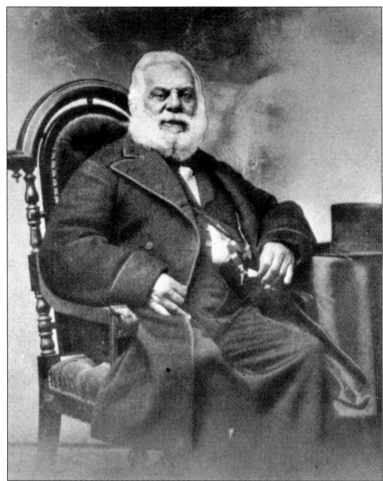

Following Mexico's independence from Spain in 1822, Mexican leaders confiscated the vast holdings of the Franciscan missions. The San Fernando Mission was secularized in 1834. In December 1845, Gov. Pio Pico, the last Mexican governor of California, granted his brother Andres Pico a nine-year lease for most of the land that today comprises the San Fernando Valley. (Courtesy San Fernando Valley Historical Society.)

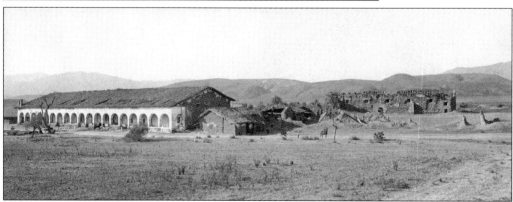

The 1834 secularization proved disastrous for the San Fernando Mission. Buildings fell into disrepair and were heavily vandalized. After obtaining his lease, Andres Pico opted to live at the old mission and enjoyed a reputation for entertaining and utilizing the mission's *convento*, or "long building," for lavish parties. Pres. Abraham Lincoln confirmed church ownership to 170 acres, including the mission buildings, in 1862. (Courtesy San Fernando Mission Archives.)

In 1846, Eulógio de Célis, a successful Los Angeles merchant, purchased the mission lands. In 1856, he failed to sell Rancho Ex-Mission San Fernando for 50¢ an acre. Following de Célis's death in 1869, his heirs sold more than 50,000 acres, including the old mission, to former state senators Charles Maclay and George K. Porter, and to Porter's cousin B. F. Porter in 1874. (Courtesy San Fernando Valley Historical Society.)

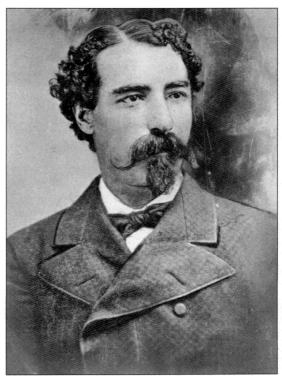

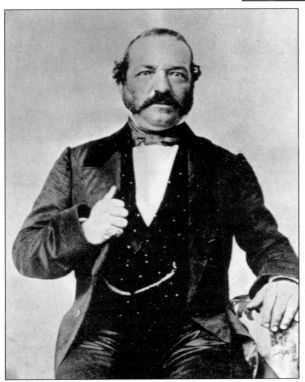

Andres Pico distinguished himself during Mexico's war with the United States, leading Mexican forces in California. On January 13, 1847, he met John C. Fremont at Campo de Cahuenga and signed the Treaty of Cahuenga. Following the war's end, Pico returned to his home at the old mission. Andres Pico remained active in California politics, including serving as state senator in the 1860s. (Courtesy San Fernando Valley Historical Society.)

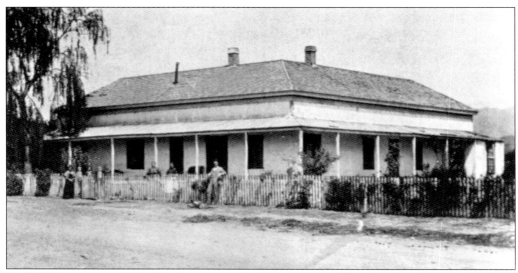

In 1861, Geronimo and Catalina Lopez bought about 40 acres of land north of the mission where they built Lopez Station. The station served as a stop on the Butterfield Overland Mail Stage Company's Los Angeles to San Francisco route. Today Lopez Station lies beneath the land once covered by the Van Norman Reservoir. (Courtesy San Fernando Valley Historical Society.)

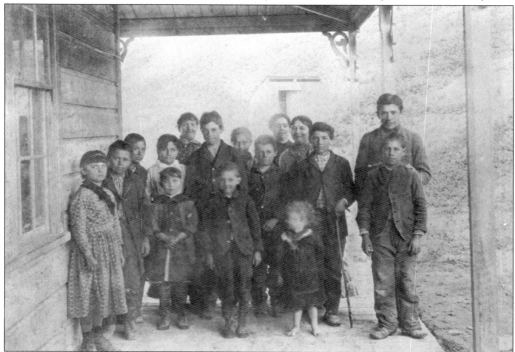

Lopez Station housed the first English-speaking school in the San Fernando Valley, with approximately 25 students regularly enrolled. The school closed in 1884. The station also served as a general store, the valley's first post office, and a popular place to rest for weary travelers. One frequent guest was the infamous bandit Tiburcio Vasquez. (Courtesy San Fernando Valley Historical Society.)

In April 1874, with financial assistance from former California governor Leland Stanford, former state senators Charles Maclay, George K. Porter, and Porter's cousin Benjamin Franklin Porter purchased Rancho Ex-Mission San Fernando. On seeing the San Fernando Valley for the first time, Maclay is said to have proclaimed, "This is Eden!" The Porters owned two-thirds of the property, the area west of present-day Sepulveda Boulevard. Maclay owned the land east of Sepulveda Boulevard, including the old mission and the area that today encompasses the City of San Fernando and Pacoima. Maclay concentrated on subdividing his property, while the Porters focused on agriculture. (Courtesy San Fernando Mission Archives.)

George Keating Porter came to California in the 1850s from New Hampshire and served as state senator for Santa Cruz. Initially the Porters engaged in dry land wheat farming. In 1881, they split their holdings with a coin toss. George won and opted for the area between present-day Sepulveda Boulevard and Aliso Canyon. B. F. Porter's land became Chatsworth and Porter Ranch. (Courtesy San Fernando Valley Historical Society.)

George Porter subdivided his land and established the Porter Land and Water Company. In 1887, Porter developed extensive irrigation systems and began experimenting with a variety of different citrus crops. He planted an area 1 mile wide and 3 miles long, which became known as the Long Orchard. This is an exceedingly rare orange crate label for the Porter Land and Water Company's Fernando oranges. (Courtesy Robert Booth.)

Fernando Oranges

PACKED BY

Porter Land & Water Company

FERNANDO, CAL.

Two

THERE IT IS. TAKE IT.
1904–1924

Adequate sources of freshwater were a constant challenge for San Fernando Valley farmers. In October 1903, Leslie C. Brand (pictured here), the "father" of Glendale, California, secured a three-year option to purchase 16,000 acres of the Porter Land and Water Company. Originally, Brand anticipated Henry Huntington's railroad would expand into the valley and create opportunity for the Porter land. But in the fall of 1904, Los Angeles city officials approved former mayor Fred Eaton and Department of Water and Power superintendent William Mulholland's plan to bring water from California's Owens Valley to Southern California—the Los Angeles Aqueduct. The approval was supposed to be confidential, but within a week, Brand and nine others (a virtual who's who of Los Angeles) formed the San Fernando Mission Land Company and exercised the option to purchase Porter's land. As word of the aqueduct spread, the value of Brand's holdings skyrocketed. Accusations and speculation of inside information began to spread. With the controversy still fresh, George K. Porter passed away on November 16, 1906. (Courtesy Special Collections Room, Glendale Public Library.)

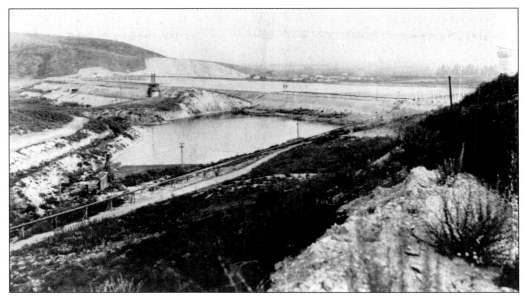

In 1912, in order to accommodate the water coming from the aqueduct, work began on the San Fernando Reservoir. Built in stages and on the former site of Lopez Station, the dam and twin reservoirs were not completed until 1950. The area was later renamed the Van Norman Dam and Reservoir after William Mulholland's associate Harvey Van Norman. (Courtesy San Fernando Valley Historical Society.)

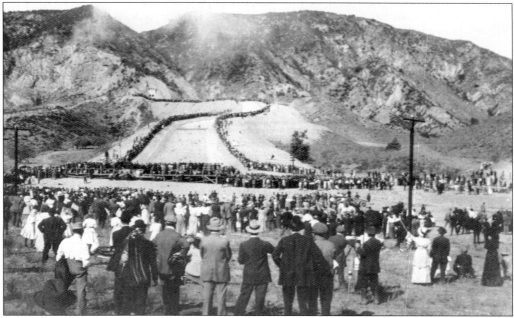

On November 5, 1913, with work completed on the Los Angeles Aqueduct, William Mulholland stood before a crowd of nearly 40,000 Los Angelenos and declared, "There it is. Take it," as water from the Owens Valley began to flow down the Cascades into the newly completed San Fernando Reservoir. The Cascades is a familiar landmark visible at the northern end of Granada Hills. (Courtesy San Fernando Valley Historical Society.)

Lured by the arrival of a virtually unlimited supply of freshwater, Charles C. Reynolds (with one of his daughters) established the Cascade Ranch (named for Mulholland's Cascades), located in the area now known as Knollwood in Granada Hills, east of Balboa Boulevard and north of Rinaldi Street. C. C. Reynolds was a partner in the successful Los Angeles hardware firm of Harper and Reynolds Company. (Courtesy Ken Morris.)

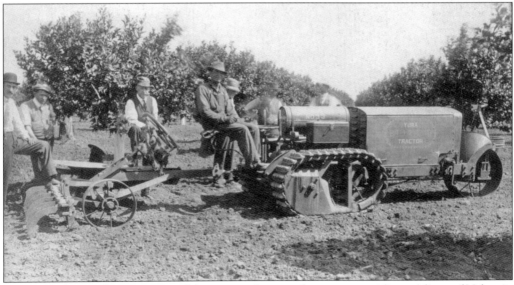

The Cascade Ranch was a successful citrus producer and nursery, providing saplings of Valencia oranges to nearby ranches and farms. The orange trees at the corner of the Cal State Northridge campus (Lindley Avenue and Nordhoff Street) are considered the oldest surviving orange grove in the San Fernando Valley. According to the *Los Angeles Times* (April 30, 2006), these trees originally came from the Cascade Ranch. (Courtesy Ken Morris.)

In 1917, a wealthy Oklahoma oilman named Mosier purchased 4,100 acres of land from the San Fernando Mission Land Company. Mosier named the area Sunshine Ranch. The ranch occupied the area bordered by Aliso Canyon (west), San Jose Street (south), Balboa Boulevard (east), and San Fernando Road (north). It has been generally accepted that the name of the founder of Sunshine Ranch was "J. H. Mosier." This name appears in all of the written accounts of Granada Hills' history. However, while researching this book, the author discovered his actual name was M. H. Mosier (Martin Henry Mosier.). Born in Punxsutawney, Pennsylvania, Mosier went to Oklahoma in 1905 where he enjoyed considerable success in the oil business. He came to Southern California in 1915. That same year, he commissioned architect John C. Austin to build a mansion in the Fremont Place area of Los Angeles. Louis Comfort Tiffany decorated the interior of the home, and in the 1960s, it was owned by boxing legend Muhammad Ali. (Courtesy Martin Henry Mosier III.)

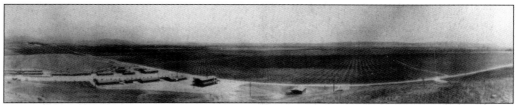

The center of operations for Sunshine Ranch was located near the present-day intersection of Rinaldi Street and Shoshone Avenue (here looking southeast in a rare pre-1920 photograph). Sunshine Ranch consisted of 35 buildings, all painted a bright orange-yellow—the color of sunshine. In addition to the main house, there were bunkhouses, a mess hall, barns, silos, and a large poultry operation. Three of the original bunkhouses (the line of buildings seen at left) are all that remain of the Sunshine Ranch structures. (Courtesy Granada Hills Chamber of Commerce.)

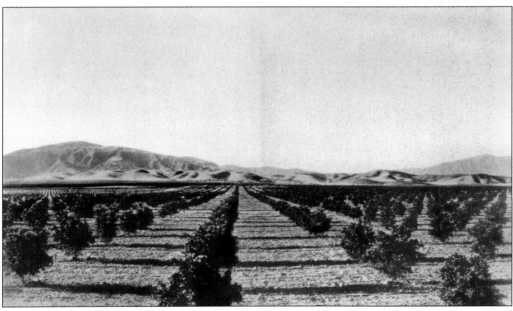

Sunshine Ranch (looking north from the approximate intersection of White Oak Avenue and Chatsworth Street in early the 1920s) was planted with 1,200 acres of citrus (oranges, lemons, and grapefruit), apricots, walnuts, beans, and alfalfa. To help enrich the already rich, dark loam, workers at the ranch regularly sowed in crushed oyster shells to enhance the calcium content of the soil. (Courtesy Granada Hills Chamber of Commerce.)

The Sunshine Ranch enjoyed a reputation as one of the largest citrus producers and ranch operations in California. This photograph shows the two silos at the ranch. Mosier was always interested in finding ways to enhance the ranch's operation and production. One of the innovations to come from the Sunshine Ranch was the development of a special variety of fruit known as the Sunshine Pummelo. (Courtesy Fred and John Weitkamp.)

SUNSHINE RANCH

The Coming Foothill Show Place of San Fernando Valley

A 4200-acre fully equipped property devoted to citrus fruits, pure-bred Holstein cattle and Hampshire swine, along with the largest commercial poultry plant in the valley.

In Frostless Belt

Aside from its location against the foothills, at altitudes free from frost, its soil properties are peculiarly adapted to the best development of tree and fruit. The 1000-acre tract now in trees is one of the inspiring sights within one hour's ride from the city of Los Angeles.

Foundation Herd of Holsteins

The environment is an ideal one for the breeding and rearing of high-class Holstein cattle, with purest of water, perfect drainage conditions as to character of soil and lay of land and unlimited range in the foothills.

The foundation stock consists of about twenty-five selected females, notable alike for a high record ancestry and the type that stands for constitutional vigor and usefulness.

As exemplifying the type of cows that are being brought to Sunshine Ranch we may name three or four of the leading cows secured at the recent Guaranty Sale at Sacramento:

Korndyke Model Hartog 2d, 344589—at $1325. She made 27.45 lbs. butter as 2-year old and has two sisters with above 1100-lb. yearly records.

Ava Hartog Pietertje 367460—at $1325. Her dam produced 1129 lbs. butter in one year.

Hengerveld Spring Pontiac Ava 458204—at $1100. She is also daughter of the 1129-lb. cow Ava Model Hengerveld 2d.

Pearl Na Dean De Kol 601299—at $1125. A junior 2-year-old giving 80 lbs. milk on day of sale, with 24.45 lbs. butter in 7 days, and winning second prize at State Fair, 1920, and second prize produce of dam.

Canary Pontiac Ardsa Burke 218243—the great Sunshine Ranch four-year-old herd sire is a close-up descendant of the only double century sire King of the Pontiacs. His sire, Sir Pontiac Ardsa Burke of Vine, was by same sire as the 44.18-lb. cow P. P. Pontiac Lass—a world's record when made.

Canary Pontiac Ardsa Burke is a bull of splendid physique, fine conformation, conventional markings and a sure sire of good calves withal.

Our year's crop of calves will also include the get of such well known transmitting sires as King Korndyke Pontiac 20th, Sir Pietertje Ormsby, Mercedes 43d, Sir Aaggie Mead, Sir Pietertje Ormsby Canary Carnaton King Sylvia and King Segis Alcartra Prilly.

SUNSHINE RANCH CO.
San Fernando, Calif.
M. H. MOSIER, Manager.

A large dairy and poultry operation was also part of the Sunshine Ranch. In 1923, the ranch was producing 2,000 eggs a day. The ranch boasted a herd of 120 prized Holsteins and more than 1,000 purebred Hampshire hogs. One cow produced a record 29,000 pounds of milk in a single year (which was eventually turned into 1,100 pounds of butter). This is an advertisement citing highlights of Sunshine Ranch's operations. (Courtesy author.)

Three

A City of Destiny . . . and Rabbits
1925–1941

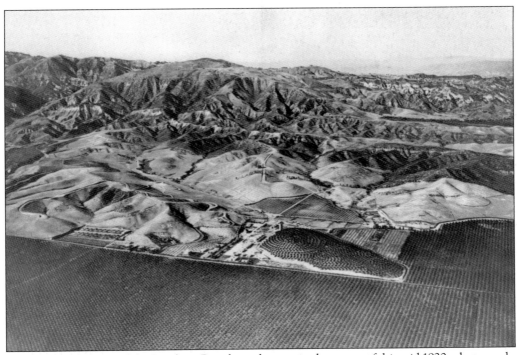

The various buildings of the Sunshine Ranch can be seen in the center of this mid-1920s photograph, and rows of the poultry operation are visible in the left center. A closer look reveals the initials "SR" (for Sunshine Ranch) on the hill between the concentration of ranch buildings and the poultry area. By 1925, M. H. Mosier decided to sell the ranch and return to the oil business. After selling to the Bayly Brothers, a Los Angeles–based investment firm, Mosier became involved in a number of oil ventures, including the purchase of one million acres of potentially oil rich land in Columbia. He remained in Southern California, where he organized and served as the head of the Petroleum Company of Los Angeles, Carpathia Petroleum Company, Satellite Oil Company, and M. H. Mosier Special and Petroleum Company. Mosier passed away in Los Angeles on February 13, 1939, at age 83. (Courtesy Granada Hills Chamber of Commerce.)

Harold and Roy D. Bayly (pictured here c. 1950) established the Los Angeles area investment firm Bayly Brothers. In 1925, they secured an option to purchase the Sunshine Ranch. In November 1925, they exercised the option and sold the ranch to developers Edwards and Wildey for approximately $1.6 million. The ranch was transferred to Suburban Estates, a corporation established by Edwards and Wildey and other investors. (Courtesy Roy D. Bayly Jr.)

Godfrey Edwards and Otto Wildey were partners in the Eagle Rock, California, development and construction company Edwards and Wildey. They were responsible for building the Los Angeles Memorial Coliseum, but Sunshine Ranch was said to be their largest development project. This brochure outlines their vision for what they called a "City of Destiny." However, a name for this new community still needed to be selected. (Courtesy San Fernando Valley Historical Society.)

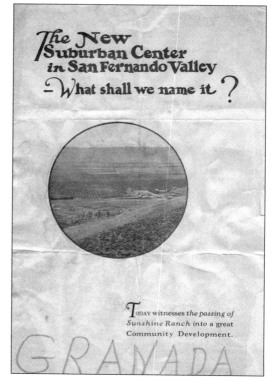

The New Suburban Center in San Fernando Valley — What shall we name it?

TODAY witnesses the passing of Sunshine Ranch into a great Community Development.

GRANADA

To generate interest in their new development, Edwards and Wildey sponsored a contest to name the town. The winning entry received a $500 cash prize. A large celebration, featuring a free "Old Time Spanish Barbeque" set for April 11, 1926, to announce the winner, was postponed a week due to rain. The committee charged with selecting the winner was composed of John Steven McGroarty (future poet laureate of California), Andrew Chaffey, C. H. Randall, R. W. Trueblood, John Bailey, Harold Bayly, and Otto Wildey. On April 18, 1926, after more than 6,000 entries, they selected Granada, because of the area's physical and climatic similarity to Granada, Spain. There is no record of who won the contest, but the committee must have had a problem—as many as 16 people were said to have recommended the winning name! (Both courtesy author.)

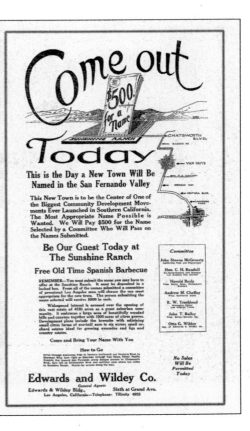

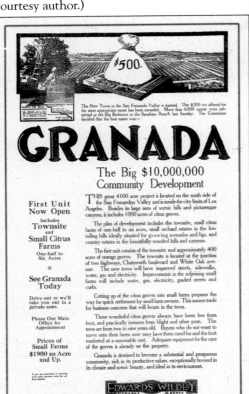

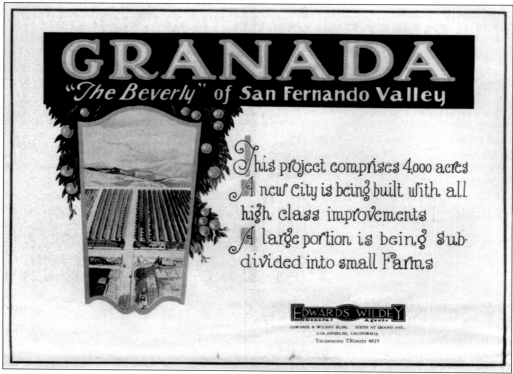

With the town's name established, Edwards and Wildey committed to making $10 million in improvements—paved roads, water, gas, and power. They planned three phases, beginning with development of 400 acres consisting of one-half to six-acre parcels. The second phase called for two to 10-acre country estates in the lower hills of the former ranch. Finally, cabin sites in the canyons and higher elevations were planned. (Courtesy author.)

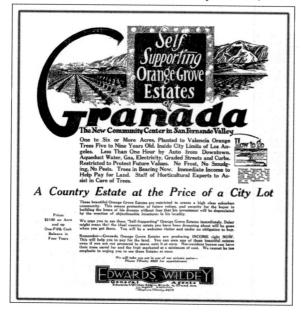

Initial sales were brisk, reaching the $1 million mark in less than three months. Lots started at $1,900 an acre and quickly rose to $2,100 an acre and more. Each of the home sites was touted as an opportunity to enjoy "country living" (less than an hour from downtown Los Angeles!) and, at the same time, own a profit-generating citrus, avocado, or fig farm. (Courtesy author.)

Thurlow Stather Culley came to Granada in 1927 as a salesman for Edwards and Wildey. Culley (shown here in the 1970s) was born in 1893 in Omaha, Nebraska, and worked at Bullock's Department Store in Los Angeles before joining Edwards and Wildey. His arrival in Granada marked the beginning of a lifelong association with the community. Longtime residents have called Culley the "George Washington" of Granada Hills. (Courtesy Carolyn Culley Clark.)

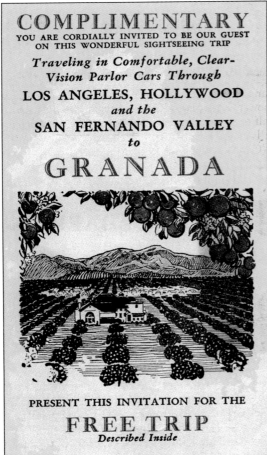

COMPLIMENTARY

YOU ARE CORDIALLY INVITED TO BE OUR GUEST
ON THIS WONDERFUL SIGHTSEEING TRIP

Traveling in Comfortable, Clear-Vision Parlor Cars Through

LOS ANGELES, HOLLYWOOD
and the
SAN FERNANDO VALLEY
to

GRANADA

PRESENT THIS INVITATION FOR THE

FREE TRIP
Described Inside

To help generate interest in Granada, Edwards and Wildey invited people to spend an afternoon and learn about the new community. At a large pavilion set up on Chatsworth Street, guests were treated to a free lunch, given a tour of available lots, and visited demonstration areas designed to show the profit potential of rabbits, poultry, and citrus. This is an invitation for one of those excursions. (Courtesy author.)

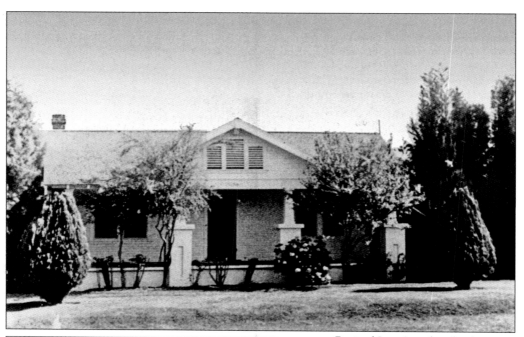

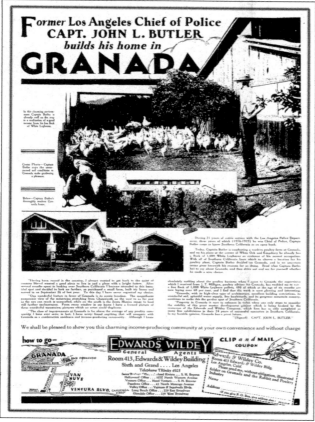

Retired Los Angeles chief of police John L. Butler owned the first house built in Granada, located at the southwest corner of White Oak Avenue and Kingsbury Street. In their continuing efforts to build interest in Granada, Edwards and Wildey ran a series of advertisements with testimonials from well-known individuals who had moved to Granada or were associated with the rabbit or poultry operations. (Above, courtesy Fred and John Weitkamp; below, courtesy author.)

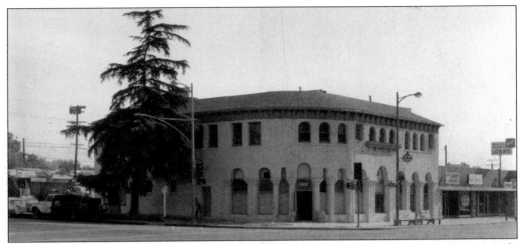

By 1927, the community began to take shape. Edwards and Wildey built a two-story, Spanish-style building called the Granada Building at the town's center—the northeast corner of Chatsworth Street and White Oak Avenue. That same year, the Granada Woman's Club was organized. A year after it began, more than 430 people had purchased property in Granada. In 1928, the chamber of commerce was formally organized. (Courtesy Granada Hills Chamber of Commerce.)

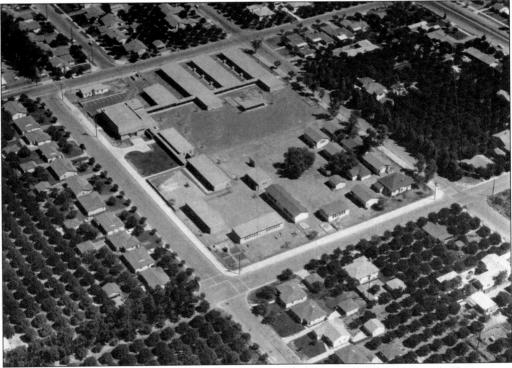

The Los Angeles Board of Education bought a 5.5-acre school site in 1927, and Granada Elementary, pictured here, opened in the fall of 1928. Speaking of children—the William Klissner family had the honor of having the first child born in Granada, a daughter, whom they appropriately named "Granada." The Granada Mortgage Company presented the family with $25 worth of stock to celebrate the occasion. (Courtesy Granada Elementary.)

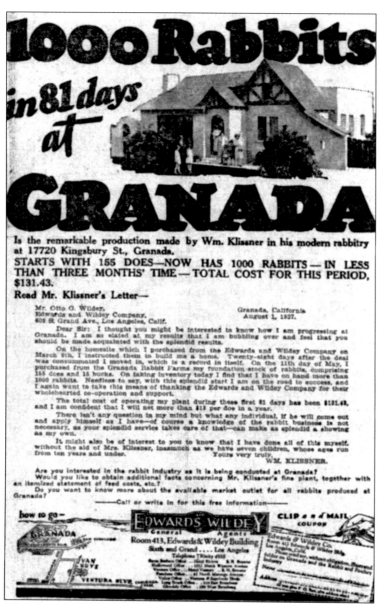

As property sales slowed, Edwards and Wildey began promoting Granada as an ideal place to raise rabbits. Four-bedroom homes on half-acre lots were offered for as low as $1,000 and came complete with a rabbitry large enough to accommodate up to 800 rabbits, 50 breeding does, and 5 bucks (guaranteed to "kindle"). The "Granada Rabbit" became recognized for its excellent meat, thanks to the effort of the Granada Rabbit Association. The first shipment of rabbit meat was sent to Eastern markets on July 23, 1927. Additionally, Granada rabbits received acclaim for their fur. In 1928, the Tilconer Rabbit Fur Farm in Granada (at 17956 San Fernando Mission Boulevard) won 40 first place awards at the Imperial Valley Midwinter Fair. C. S. Tilton and C. M. Falconer owned the Tilconer farm. This advertisement offers a testimonial to the success enjoyed by William Klissner, an early Granada resident. Not interested in rabbits? No problem—Edwards and Wildey offered a similar all-inclusive package for poultry as well! (Courtesy Steve Biderman.)

In 1928, Edwards and Wildey sponsored a contest to make as many words as possible from the phrase "Granada, The New City." The winner received free title to a lot in Granada. Six hundred additional prizes, credits toward the purchase of a lot, were also awarded, but there is no record of who won. In an unfortunate sign of the times, only "members of the Caucasian race" could enter. (Courtesy author.)

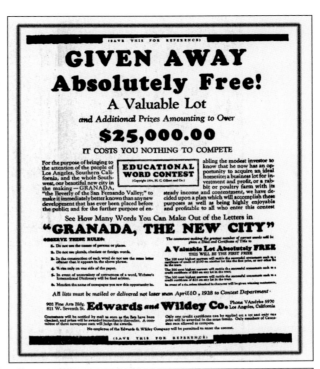

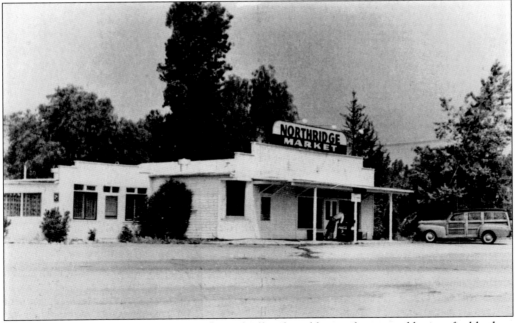

By 1929, Granada had come to a virtual standstill—the rabbit market proved less profitable than hoped, and the distance to Los Angeles too great. In 1932, Granada Elementary closed, and its bungalows were sent to Long Beach after the 1933 earthquake. Construction had come to a virtual stop except for A. G. Rowland's market at the corner of Zelzah Avenue and Devonshire Street in 1933 (seen here as Northridge Market in the 1940s). (Courtesy Fred and John Weitkamp.)

Suburban Estates went into receivership in 1932, ending Edwards and Wildey's association with Granada. Godfrey Edwards passed away in 1928. Otto Wildey, an avid yachtsman (and first president of the California Yacht Club), took time to go sailing. In 1934, actress Mary Pickford, "America's Sweetheart" and an original investor in Suburban Estates, sued and won a $25,000 judgment against the company. Otto Wildey died in 1942. (Courtesy author.)

Thurlow Culley and his wife, Brooksy, stayed in Granada and, according to Granada Hills historian Ken Morris, became the "accepted arbiter and go-between" for Granada's citizens and Suburban Estates, Edwards and Wildey, and Granada Mortgage. He also provided a host of other services, including real estate sales, property management, and rent collection. He operated out of the original Edwards and Wildey office at 17645 Chatsworth Street. (Courtesy Culley family.)

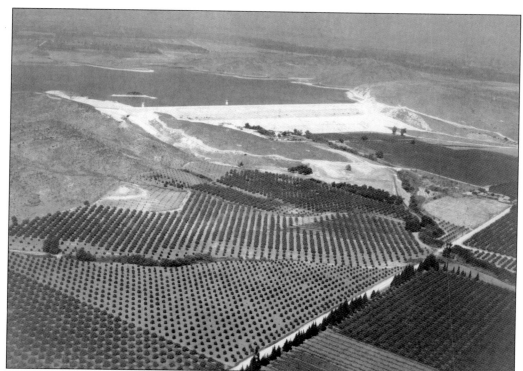

This is a 1930 aerial view of the eastern area of Granada Hills, then known as the Elerath Ranch. The Van Norman Dam and the lower San Fernando Reservoir are clearly visible. Rinaldi Street runs across the right corner of the photograph. In 1945, residents successfully fought an effort by Los Angeles to place an alcoholic rehabilitation camp on public land below the dam. (Courtesy Granada Hills Chamber of Commerce.)

In the late 1930s, attorney John O'Melveny, son of the founder of the venerable Los Angeles law firm O'Melveny and Meyers purchased 672 acres north of the town of Granada. Named the C and J Ranch (Corrine and Jack), O'Melveny used the land for raising cattle and as a weekend country retreat. (Courtesy O'Melveny and Meyers, LLP.)

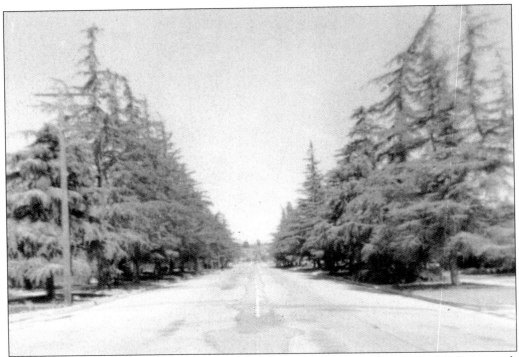

Even after the sale of the Sunshine Ranch, poultry and citrus operations continued. In 1931, ranch superintendent John Orcutt obtained deodar cedar saplings from Teague's Nursery in Woodland Hills to improve the ranch's main entrance, purportedly receiving the trees in exchange for fertilizer produced at Sunshine Ranch. The trees were planted along White Oak Avenue, between San Jose Street and San Fernando Mission Boulevard. (Courtesy Sharon Klek.)

In 1933, Sunshine Ranch superintendent C. L. Crumrine (John Orcutt's successor) oversaw the planting of eucalyptus trees on the south side of each of Granada's main east and west streets to serve as a windbreak for the citrus groves. Here Kingsbury Street (c. 1950) shows how these trees coexisted. Many of the eucalyptus trees remain today—another living reminder of the Sunshine Ranch. (Courtesy Lorraine Haas Richardson.)

After Suburban Estates went into receivership, California Trust Company took responsibility for the sale of the remaining properties. The home sites, now called Granada Orange Estates, extended beyond the original boundaries of Edwards and Wildey's development, east to Balboa Boulevard and north of Rinaldi Street. Lots that had sold for $1,000 (including rabbits or chickens) were being liquidated for $295 (and no livestock). In 1934, Edgar H. Selecman acted as director of sales for Granada Orange Estates. Selecman had established a reputation for his efforts developing North Hollywood and parts of Northridge. Harold E. Phelps (a former Edwards and Wildey employee) succeeded Selecman in 1939. By May 1940, California Trust reported that only 15 of the original lots in Granada Orange Estates remained unsold. Edgar Selecman passed away in 1946. (At right, courtesy author; below, courtesy Suzanne Selecman Adams.)

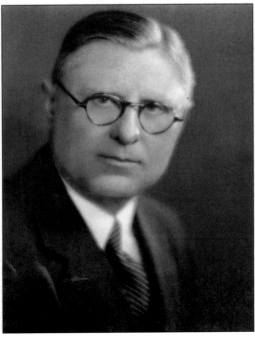

Home sales in Granada continued slowly throughout the 1930s. In 1936, the Morris family moved to 17486 Horace Street. Kenneth Morris worked for the Reynolds family of Cascade Ranch for many years. One of his earliest duties was to dig out the original section of Balboa Boulevard, north of Rinaldi Street. He later served as driver for C. C. Reynolds and his family. (Courtesy Ken Morris.)

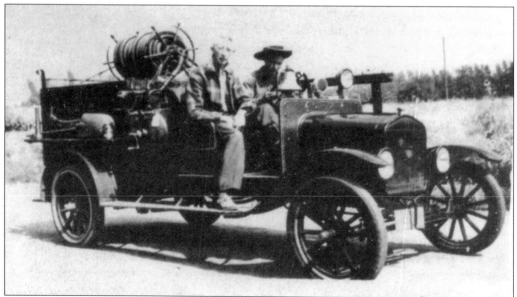

Bert Powell, pictured here on the left sitting in Granada's Model TT fire truck, served as chief of the volunteer fire department. Powell lived at San Fernando Mission Boulevard and Zelzah Street, one of Granada's highest elevations. Ken Morris recalls running with other boys to the station when the fire bell sounded and riding along, knowing they would need to help push the truck back to Powell's garage. (Courtesy Granada Hills Chamber of Commerce.)

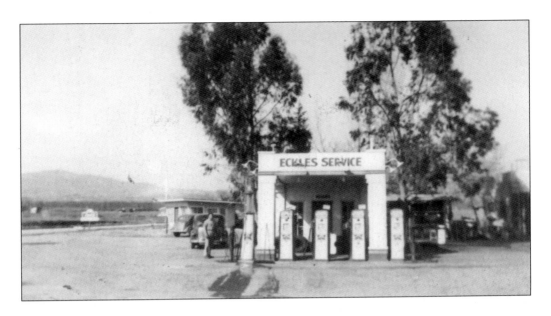

Alden E. Eckles purchased 10 acres of land at the northeast corner of Devonshire Street and Balboa Boulevard in 1925 for a truckload of hay. According to his son Charles, the land was the worst he had ever seen: "It wouldn't even grow weeds." In the late 1930s, A. E. Eckles purchased, for $115, a gas station building located at 14478 Ventura Boulevard and moved it to his corner property. He started Eckles gas station, the first one in the area (above) and eventually opened a small two-table, four-seat restaurant on the Balboa Boulevard side of the property (below). Today the northeast corner of Devonshire Street and Balboa Boulevard is one of the major intersections in the San Fernando Valley. (Both courtesy Charles P. Eckles.)

In 1938, Otto W. Baty (above) migrated to Granada from Fresno, California. The Baty family built their home and cultivated 40 acres of citrus trees at 10721 Zelzah Avenue—today the site of the Granada Village Shopping Center, the northwest corner of Chatsworth Street and Zelzah Avenue (below). Baty established the Otto W. Baty Company, known locally as Baty's, one of the San Fernando Valley's most successful commercial fumigation services for local citrus orchards. (Both courtesy Marilyn De Freitas Baty.)

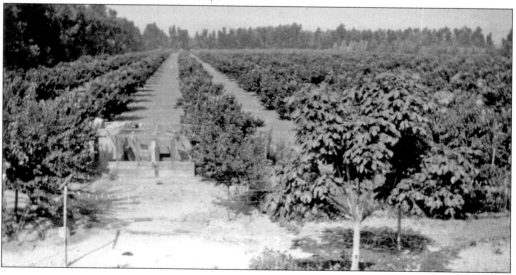

Roy and Ruth Phillips moved to Granada in the 1930s. According to their son Don (at right with his mother at the corner of Los Alimos Street and Shoshone Avenue), his formative years in Granada (Hills) were from about 1935 to 1955. He fondly recalls the scent of oranges in the warm summer air and the sense of truly living out in "the country." The photograph below shows a young Don Phillips on Christmas Day 1939 on Zelzah Avenue (looking north). According to Phillips, the field across Zelzah Avenue is where Pete Raagaard had a commercial flower operation. Phillips remembers the surface of Zelzah Avenue being oil, rather than asphalt. Many of Granada's streets were actually paved with a mixture of oil from nearby Newhall and crushed shells, from a shell deposit found at the east end of Mayerling Street. (Both courtesy Don Phillips.)

Joe Rundberg and his family moved to 17741 Ludlow Street, the northeast corner of Ludlow Street and Yarmouth Avenue, in the fall of 1941. Like many Granada residents, the Rundberg's had rabbits, dozens of chickens, some turkeys, and ducks. According to Joe's son Bill, the "total creature count was about 200." The Rundberg children, June and Bill, are pictured here at their home around 1944. (Courtesy William Rundberg.)

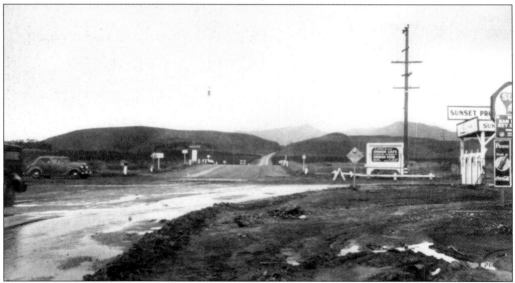

Development of the northern San Fernando Valley was occurring slowly. This is the intersection of San Fernando Mission Boulevard and Sepulveda Boulevard in 1941. Looking north is the eastern edge of the Spanish missionaries' "Enchanted Hills." Most of the growth in what was to become Granada Hills was happening a few miles east of this intersection. In the years to come, this would all change. (Courtesy San Fernando Valley Historical Society.)

Four

BUILDING A COMMUNITY
1942–1950

The United States' entry into World War II had an immediate impact on Granada, just as the town was beginning to emerge from the effects of the Great Depression. All major construction came to a halt, rationing of things like gasoline and rubber (for tires) caused people to think twice about living so far from Los Angeles, and many of Granada's young men rushed to enter the service (including high school students who were allowed to accelerate their high school graduation). On the home front, when the sirens sounded, air-raid wardens patrolled the streets to insure compliance with "lights out" procedures. Here Mary De Frietas (in the gas mask) and her sister Josephine Ellspermann take time out from raising money for the war effort to "defend" the De Frietas home at 17612 Tulsa Street. Another significant change came to Granada in 1942. To avoid confusion with the northern California town of Grenada, the United States Post Office requested Granada change its name. The community decided on Granada Hills. (Courtesy Marilyn De Freitas Baty.)

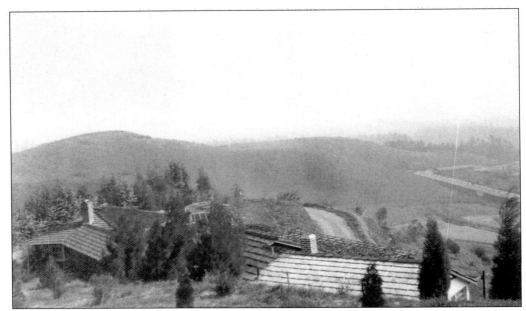

Some construction continued during the war, like the home of David C. Brown on Vimy Road, north of Rinaldi Street, east of Zelzah Avenue. Here, looking east over the top of the Brown home, a portion of Sunshine Ranch's poultry operation can be seen. Thurlow Culley, who participated in the Battle of Vimy Ridge (France) during World War I, is likely responsible for naming this road. (Courtesy Melissa Brown Biderman.)

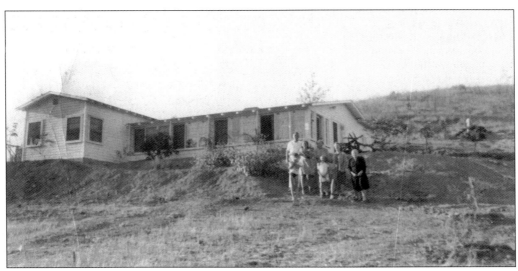

Walter and Ora Elerath, whose family owned the Elerath Ranch east of Hayvenhurst Avenue, built a home at 17847 Rinaldi Street in 1942. Both Walter and Ora were local area doctors with a reputation for providing house calls and services without regard for whether they would be paid. Walter also provided medical services to Japanese Americans interned during World War II. (Courtesy Dave Weiland.)

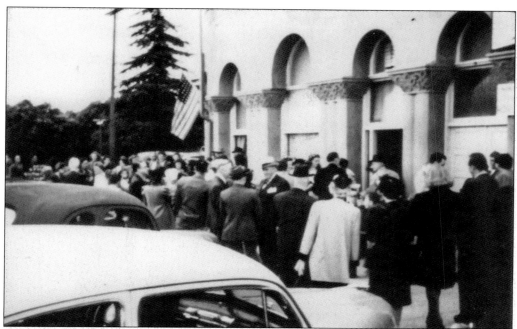

Since its construction in 1927, the Granada Building at the corner of Chatsworth Street and White Oak Avenue housed a number of businesses, as well as a lending library. More importantly, it served as the social center of the community with events attended by most everyone. Here people gather for one such event in the 1940s. (Courtesy Granada Hills Chamber of Commerce.)

In 1940, the chamber of commerce designated the last two weeks of April as Orange Blossom Festival time—a chance for Southern Californians to visit and enjoy the area's more than 500 acres of orange trees. After only two festivals, the chamber cancelled the event due to the war. In 1947, it was revived, but the annual celebration ended a few years later. (Courtesy Granada Hills Chamber of Commerce.)

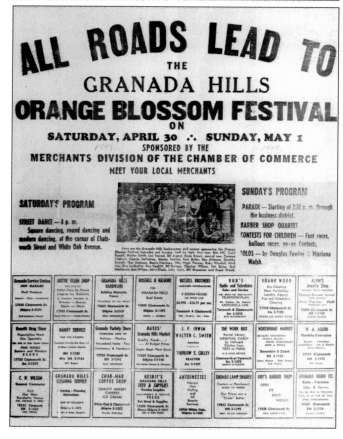

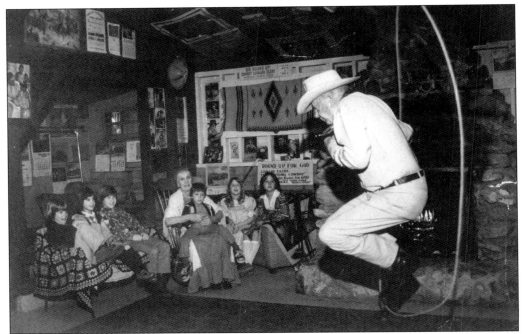

In 1942, Leonard Eilers ("The Preachin' Cowboy") established his North Rim Ranch north of San Fernando Mission Boulevard. Eilers Ranch, as it is also known, was a gathering place for the community and a refuge for Southern California children. Eilers is performing one of his famous rope tricks at home with his wife, Frances (c. 1979). Before establishing his unique ministry, Eilers worked in Hollywood. (Courtesy Joy Eilers.)

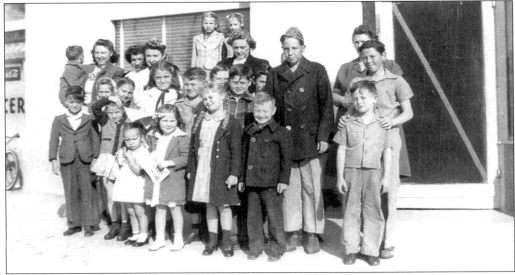

The Granada Hills Community Church met at Eilers Ranch for over two years. According to Don Phillips (lower right), Sunday school met at locations around the community. The class poses outside the Granada Building in 1944. The Eilerses' children, Joy (above top left) and Len (tall boy with hat) attended the Granada Hills Sunday school when gasoline rationing prevented them from attending their regular Hollywood church. (Courtesy Don Phillips.)

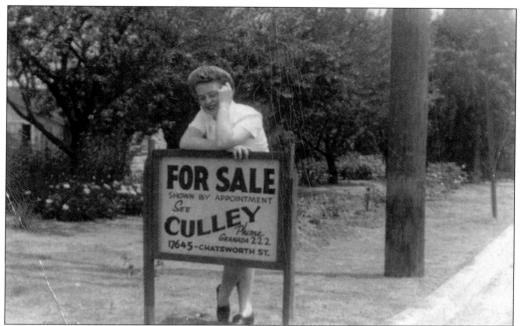

As the war continued, the rationing of gasoline and rubber tires further isolated residents of Granada Hills. In 1944, concerned about being able to provide transportation to San Fernando High School for their 14-year-old daughter Myrna (seen here posing with the Culley Realty sign), Kenneth and Martha Morris decided to sell their Horace Street home and move closer to the high school. (Courtesy Myrna Morris Roque.)

In 1945, after the victory over Germany, children at Eilers Ranch decided to hold a special Fourth of July parade. According to Joy Eilers, many of the children taken in by the Eilerses during the war were from homes where the father was fighting overseas and the mother went to work to help provide for the family. (Courtesy Joy Eilers.)

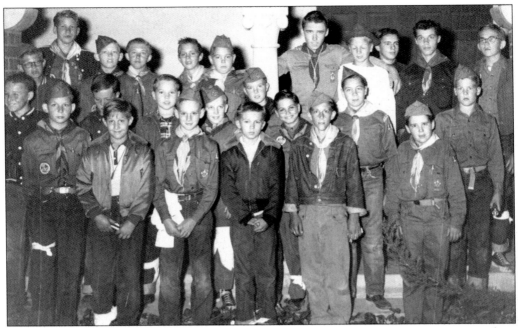

Granada Hills' first Boy Scout troop, Troop 107, was started in 1945. Here the troop gathers at First Presbyterian Church in the early 1950s. (Courtesy First Presbyterian Church of Granada Hills.)

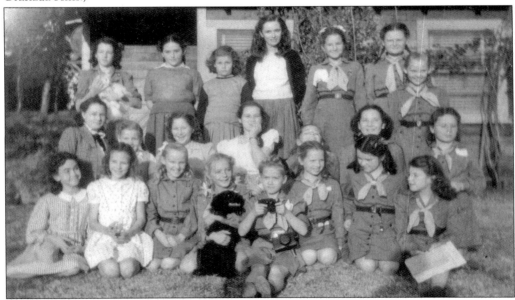

Granada Hills' first Girl Scout troop, Troop 76, is gathered at Eilers Ranch in 1946. Pictured are, from left to right, the following: (first row) Susan Reynard, Marlene Hess, Gwen Anderson, Karen Darnley, three unidentified, and Nancy Kern; (second row) Diana Kellerman (sister of actress Sally Kellerman), Joy Eilers, Hannah Moore, Paula Zimmerman, Ruth Elerath, Shirley Kaplan, and Barbara Hoag; (third row) Will Ann Forrest, Elizabeth Miller, Karen Beskow, Barbara Westman, Jackie Arave, Kara Lynn Cossell, and Joan Couch. (Courtesy Joy Eilers.)

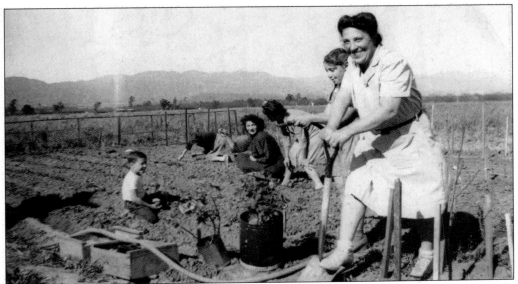

The Mattina family arrived in Granada Hills in 1943. According to Jerry Mattina, compared with Brooklyn, New York, Granada Hills with its farms and orange groves "was a dream come true." Here, in 1945, Jerry's mother, Martha, is planting the family garden at their home on the northwest corner of Devonshire Street and Hayvenhurst Avenue. The top of the San Fernando Reservoir Dam can be seen in the distance. (Courtesy Jerry Mattina.)

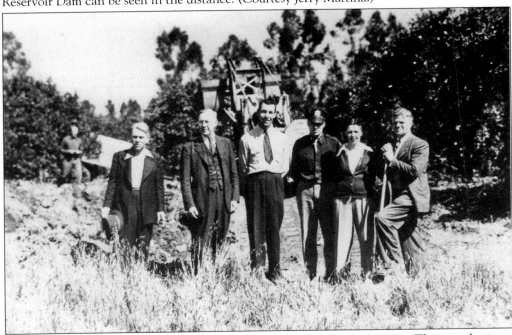

With the war over, citizens of Granada Hills saw opportunity on the horizon. The main business district on Chatsworth Street had not seen any significant new construction since the Depression. In March 1946, ground was broken for a much needed local grocery store. Pictured are, from left to right, Walter Smith, John Irwin, Emerson "Pat" Bates, Maj. Alvin Kleeb, Erica Bates, and Thurlow Culley. (Courtesy Fred and John Weitkamp.)

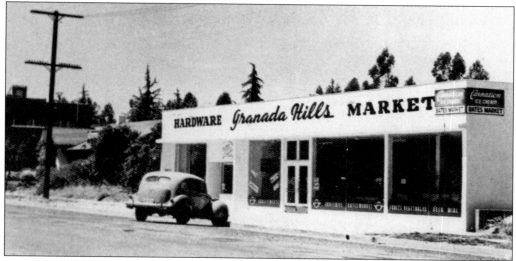

Granada Hills Market (later renamed Bates Market in the 1950s) was located at 17629 Chatsworth Street and became a familiar landmark to people living in Granada Hills. Building space was shared with Bob Grossman's Granada Hills Hardware until it was remodeled in the 1950s. Pat and Erica Bates, at the grand opening of their market in 1946, were active in the community for many years. Soon other local markets were built to serve Granada Hills—the Northridge/Downs Market (site of A. G. Rowland's market at Zelzah Avenue and Devonshire), Peter Pan Market (17743 Chatsworth Street, not to be confused with the Peter Pan Dairy of the 1960s), and the Balboa Market (corner of Chatsworth and Balboa Boulevard). In time, these markets would give way to the larger supermarket chains. (Both courtesy Robert Bates.)

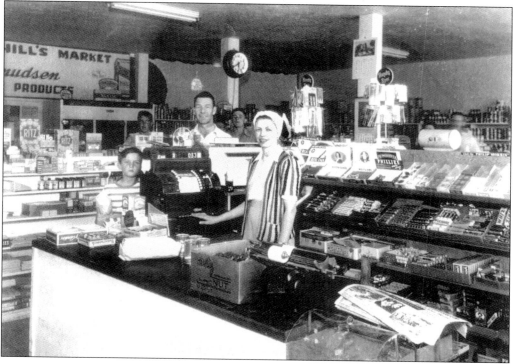

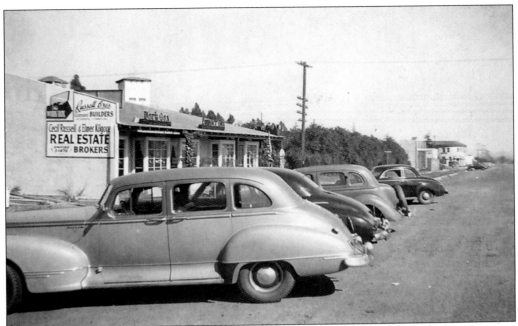

Soon after the Granada Hills Market was completed in 1946, the Granada Radio Company building (17825 Chatsworth Street) and the Russell Building (17805 Chatsworth Street) were built. This photograph shows the Russell Building at the corner of Chatsworth Street and Yarmouth Avenue, looking east toward the Granada Building. (Courtesy Jerry Shallenberger.)

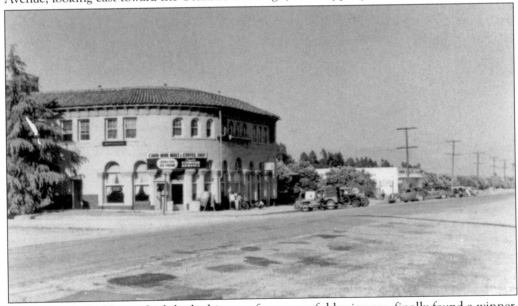

The Granada Building, which had a history of unsuccessful businesses, finally found a winner. The building had apartments upstairs (rumors have persisted about what went on in some of those apartments—rumors, which the author has been reliably told, are in fact true) and space for three businesses downstairs. In 1946, Mary De Freitas decided to open a restaurant next door to Nesbit's Feed Store. (Courtesy Granada Hills Chamber of Commerce.)

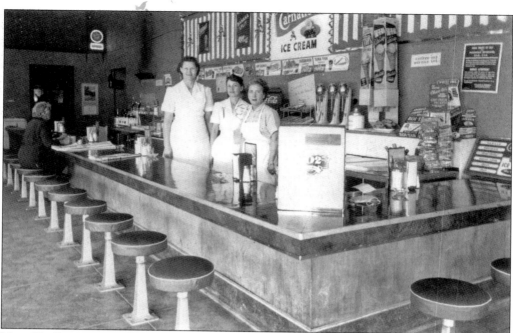

Mary De Freitas named her new restaurant Char-Mar Malt and Coffee Shop. Char-Mar is a combination of the names of her two children, Charles and Marilyn. The Char-Mar was an immediate hit. The above photograph shows the fountain area, with Mary at the far right. Mary's husband, Charles, built the counter and installed the stools. The Char-Mar dining area (in the center of the building) served for many years as a local community room. St. John Baptist de la Salle held their first masses in the dining room. When Nesbit's Feed Store closed, Mary occupied the remaining space and opened a bar. That is Mary to the left; the patron is unidentified. Mary De Frietas sold the Char-Mar in 1955. (Both courtesy Marilyn De Freitas Baty.)

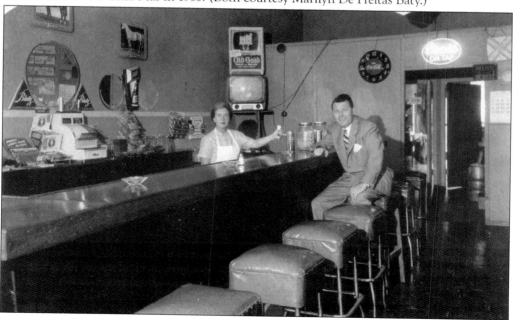

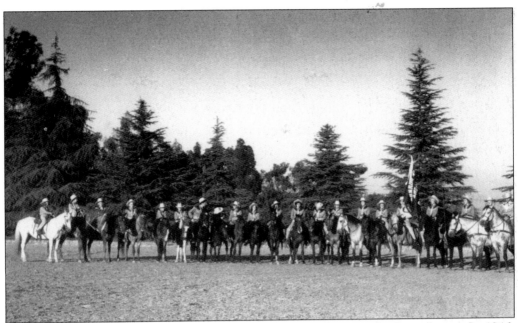

The "country life" offered by Granada Hills was a natural setting for horse lovers. In 1946, Roy Phillips formed a group for young riders, in association with the North Valley Horsemen's Association, called the Saddle Dusters, pictured here in 1947 on Zelzah Avenue at the future site of the First Presbyterian Church of Granada Hills. Roy Phillips and his son Don can be seen at the far right of the above photograph. The Saddle Dusters and a related group, the Granavahoes, would often ride in local parades. In the late 1940s, a group of the kids rode in a parade in Santa Barbara. Below, a group of Saddle Dusters ride down an unidentified Granada Hills street (possibly Shoshone Avenue). (Above, courtesy Don Phillips; below, courtesy Jerry Shallenberger.)

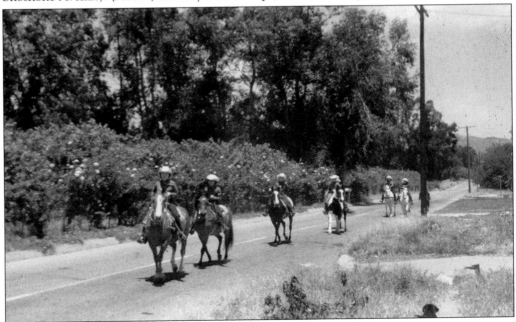

Sometimes horses provided a more practical use; here William Shallenberger takes one of his sons and three neighbors out trick-or-treating on Halloween in the late 1940s. The street is unidentified, though it is likely Shoshone Avenue, where the Shallenberger's had a home. (Courtesy Jerry Shallenberger.)

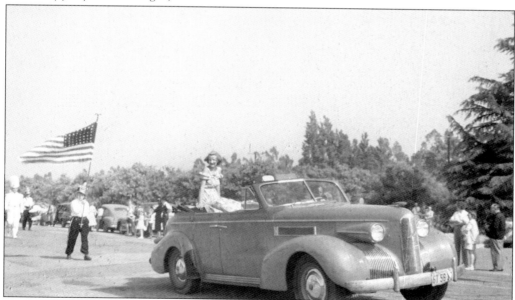

Granada Hills has a long history of holding local parades down Chatsworth Street. This photograph is from the late 1940s and is likely the parade associated with the Orange Blossom Festival that was revived following the end of the war. (Courtesy Jerry Shallenberger.)

North of Rinaldi Street is a tributary to the Los Angeles River known as Bull Creek. In the 1960s, in the interest of public safety, much of Bull Creek was encased in concrete and turned into a flood-control channel. This was not the case in the 1940s. Behind what is today the North Valley Jewish Community Center was a place known to locals as the "Old Swimming Hole," created by a small irrigation dam on Bull Creek. The Old Swimming Hole was found on the Elerath Ranch, which was owned by Dr. Walter Elerath. Here members of the Elerath family are enjoying the Old Swimming Hole. At right is Walter's daughter Ruth Elerath with friends. The image below shows his eldest daughter Amy Lou Elerath with Norbert Weiland, whom she met at the Old Swimming Hole in 1947 and married less than a year later. Norbert Weiland would go on to build a number of homes around Granada Hills that still stand today. (Both courtesy Dave Weiland.)

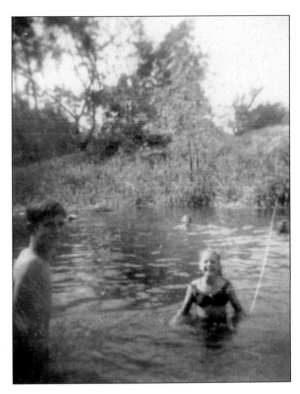

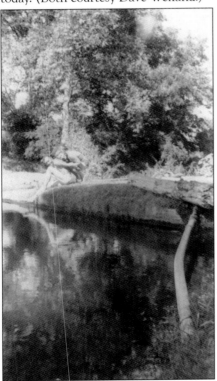

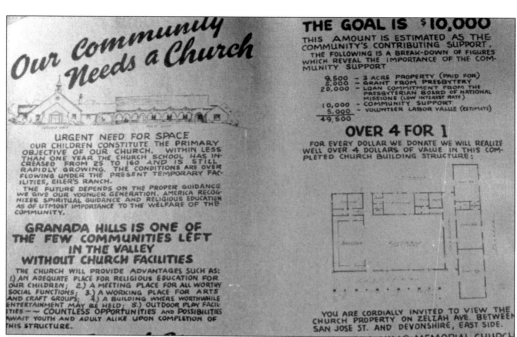

Our Community Needs a Church

THE GOAL IS $10,000

THIS AMOUNT IS ESTIMATED AS THE COMMUNITY'S CONTRIBUTING SUPPORT.

THE FOLLOWING IS A BREAK-DOWN OF FIGURES WHICH REVEAL THE IMPORTANCE OF THE COMMUNITY SUPPORT

9,500	3 ACRE PROPERTY (PAID FOR)
5,000	GRANT FROM PRESBYTERY
20,000	LOAN COMMITMENT FROM THE PRESBYTERIAN BOARD OF NATIONAL MISSIONS (LOW INTEREST RATE)
10,000	COMMUNITY SUPPORT
5,000	VOLUNTEER LABOR VALUE (ESTIMATE)
49,500	

URGENT NEED FOR SPACE

OUR CHILDREN CONSTITUTE THE PRIMARY OBJECTIVE OF OUR CHURCH. WITHIN LESS THAN ONE YEAR THE CHURCH SCHOOL HAS INCREASED FROM 25 TO 160 AND IS STILL RAPIDLY GROWING. THE CONDITIONS ARE OVERFLOWING UNDER THE PRESENT TEMPORARY FACILITIES, EILER'S RANCH.

THE FUTURE DEPENDS ON THE PROPER GUIDANCE WE GIVE OUR YOUNGER GENERATION. AMERICA RECOGNIZES SPIRITUAL GUIDANCE AND RELIGIOUS EDUCATION AS OF UTMOST IMPORTANCE TO THE WELFARE OF THE COMMUNITY.

GRANADA HILLS IS ONE OF THE FEW COMMUNITIES LEFT IN THE VALLEY WITHOUT CHURCH FACILITIES

THE CHURCH WILL PROVIDE ADVANTAGES SUCH AS: 1) AN ADEQUATE PLACE FOR RELIGIOUS EDUCATION FOR OUR CHILDREN; 2) A MEETING PLACE FOR ALL WORTHY SOCIAL FUNCTIONS; 3) A WORKING PLACE FOR ARTS AND CRAFT GROUPS; 4) A BUILDING WHERE WORTHWHILE ENTERTAINMENT MAY BE HELD; 5) OUTDOOR PLAY FACILITIES — COUNTLESS OPPORTUNITIES AND POSSIBILITIES AWAIT YOUTH AND ADULT ALIKE UPON COMPLETION OF THIS STRUCTURE.

OVER 4 FOR 1

FOR EVERY DOLLAR WE DONATE WE WILL REALIZE WELL OVER 4 DOLLARS OF VALUE IN THIS COMPLETED CHURCH BUILDING STRUCTURE:

YOU ARE CORDIALLY INVITED TO VIEW THE CHURCH PROPERTY ON ZELZAH AVE. BETWEEN SAN JOSE ST. AND DEVONSHIRE, EAST SIDE.

After the war, Granada Hills still lacked a formal place where residents could gather for worship. This is a 1947 flyer soliciting donations to build the Granada Hills Memorial Church, the first church in Granada Hills. The Memorial Church, later renamed First Presbyterian Church of Granada Hills, is located on Zelzah Avenue between San Jose Street and Devonshire Street. (Courtesy First Presbyterian Church of Granada Hills.)

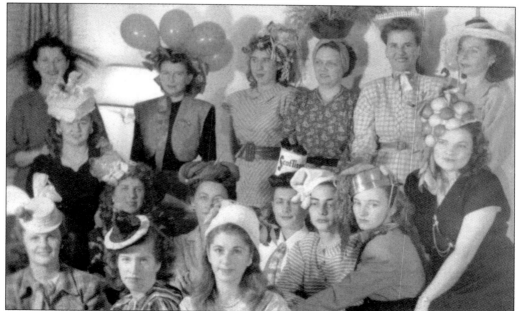

On April 7, 1947, the Granada Hills Junior Woman's Club was founded, under sponsorship of the Granada Hills Woman's Club. Here original members of the club have fun at an Easter bonnet party. (Courtesy Marilyn De Freitas Baty.)

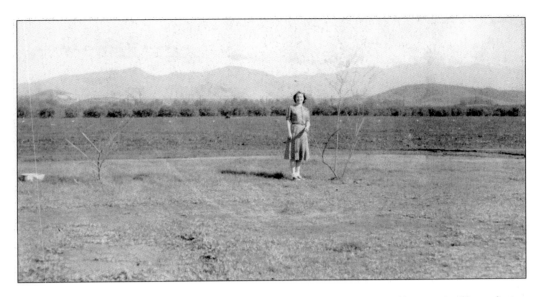

By the end of the 1940s, Granada Hills was beginning to spread well beyond its original boundaries. Newly married Norbert and Amy Lou Weiland, anxious for a place of their own, found the ideal plot of land south of the family's Elerath Ranch. Above, Amy Lou is standing on what would become their 16116 Tulsa Street home. The hill that would eventually become home to the Odyssey Restaurant is clearly visible in the background. Below is a view from the completed home in which Mission Point is visible to the west. This also shows very little development between the Weiland's new home and the rest of Granada Hills. This would change considerably within 10 years. (Both courtesy Dave Weiland.)

Norbert Weiland anticipated family members would visit Southern California from his native Chicago. To ensure they had a place to stay, he built what he called the Balboa Court Apartments at 10715–10727 Balboa Boulevard. Members of the family did come and eventually settled in and around Granada Hills. (Courtesy Dave Weiland.)

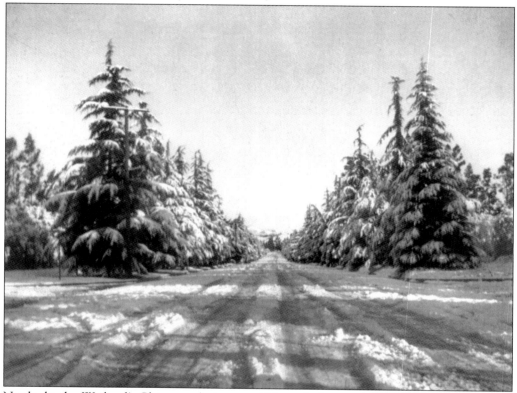

No doubt the Weiland's Chicago relatives would have had second thoughts about moving to Granada Hills if they had arrived on January 9, 1949, when Southern California experienced a rare snowfall that lasted for three days. Here John Orcutt's deodars along White Oak Avenue look more like a Currier and Ives Christmas card then the entrance to a ranch named Sunshine. (Courtesy Robert Bates.)

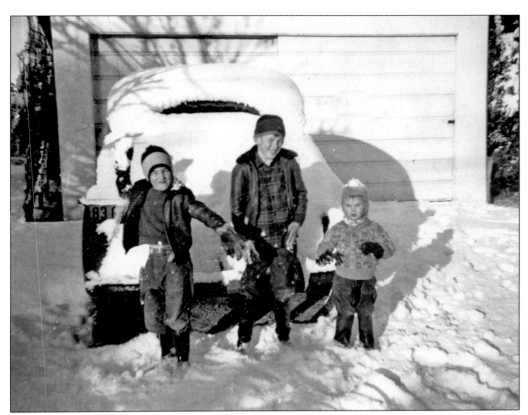

The 1949 snowstorm lasted for three days, and parts of the San Fernando Valley reported close to a foot of snow. Chains were needed on some local roads, and school was cancelled. The decision to cancel school was probably just a formality if Bob, Bill, and Jerry Shallenberger (above) were any example. Kids across the valley reveled in a rare winter blast. Citrus growers, like Otto Baty were less excited, as a record cold snap had preceded the snow a few days earlier and threatened their crops. The Baty orange grove west of Zelzah Avenue is pictured at right. (Above, courtesy Jerry Shallenberger; below, courtesy Marilyn De Freitas Baty.)

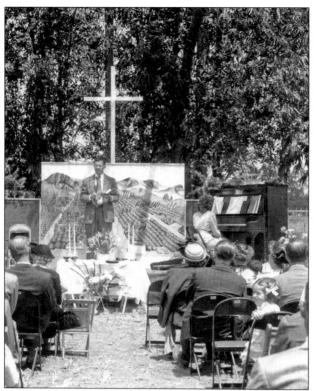

The effort begun in 1947 to raise money for Granada Hills' first formal place of worship was beginning to bear fruit. In October 1948, the congregation approved the purchase of a little more than three acres of land on Zelzah Avenue. On April 17, 1949, the congregation held an open-air Easter service on their newly acquired land, led by Rev. Alfred McNair. Take a close look at the backdrop of the photograph at left, behind Rev. McNair. It is a wonderful mural of the Granada orange orchards looking north up White Oak Avenue. It is interesting to note that the first Easter service for this congregation took place two years earlier, April 21, at the home of William Shallenberger (11515 Shoshone Avenue). (Both courtesy First Presbyterian Church of Granada Hills.)

On July 8, 1949, Granada Hills took another step toward establishing its unique identity when Thurlow Culley published the community's first newspaper. Initially the paper lacked a name, which is why the banner is filled with question marks. A contest was held to determine the eventual name—*Granada Hills Outlook*. (Courtesy Granada Hills Chamber of Commerce.)

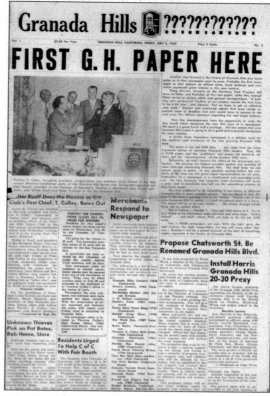

On July 31, 1949, members of the Granada Hills Memorial Church (later First Presbyterian Church of Granada Hills) gathered to formally break ground for what was to become Granada Hills' first church. Pictured are, from left to right, Floyd Brewster (architect), Emma West, Elizabeth Miller, and Rev. Alfred McNair. (Courtesy First Presbyterian Church of Granada Hills.)

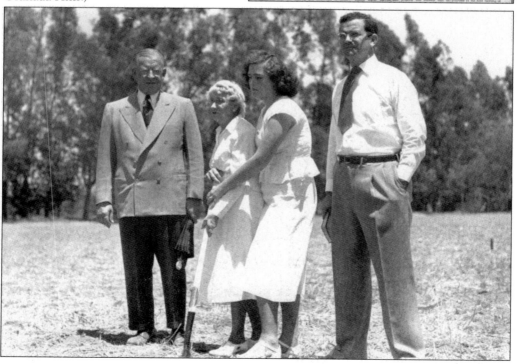

On March 19, 1946, a meeting was held at the home of Henry and Emma West (10869 White Oak Avenue) to begin organizing the community's first church. In late 1947, the congregation began to meet regularly at Eilers Ranch, and on February 26, 1950, Granada Hills Memorial Church was formally dedicated. In 1955, the church changed its name to First Presbyterian Church of Granada Hills. Below is a gathering of some of the earliest members of the congregation of Granada Hills Memorial Church. Pictured are, from left to right, the following: (first row) Carl Koons, Thomas Decker, Floyd Balding, Maynard Solt, Margaret Rizer, Mrs. Cecil Hawkins, Edwin Hardin, and Walter Ott; (second row) Miles Von Heeder, Harvey Schlepp, William Roberts, Rev. Alfred McNair, Albert Green, and Thurlow Culley. (Both courtesy First Presbyterian Church of Granada Hills.)

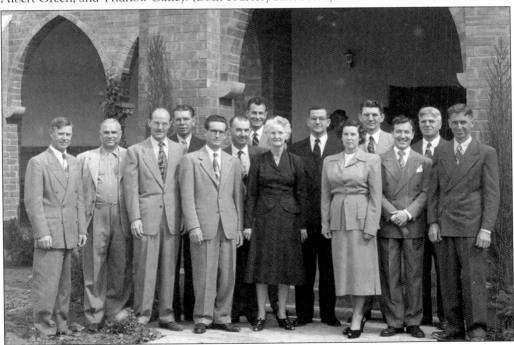

Five

BABY BOOM AND BOOMTOWN
1951–1970

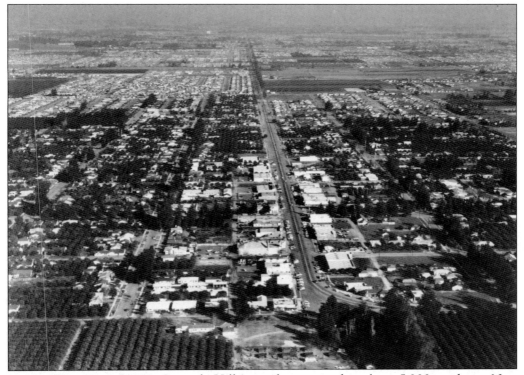

By the beginning of 1950, Granada Hills' population stood at about 5,000 residents. New neighborhoods were planned and, thanks to the infrastructure Edwards and Wildey had put into place, Granada Hills was better prepared than many San Fernando Valley communities for the growth to come, thanks to the postwar baby boom. Here is Granada Hills' primary business district in 1957, looking east down Chatsworth Street. At this time, Chatsworth Street did not continue west. Instead, it curved south onto Zelzah Avenue (as seen above). On at least two occasions, the Granada Hills Chamber of Commerce has tried, unsuccessfully, to persuade the City of Los Angeles to change the name of Chatsworth Street. In 1949, as the community was beginning to develop, they sought to change the name to Granada Hills Boulevard, to avoid confusion with the community of Chatsworth at the west end of the valley. In 1970, the chamber tried again, this time advocating Eisenhower Boulevard in honor of the former president who had passed away earlier that year. (Courtesy Fred and John Weitkamp.)

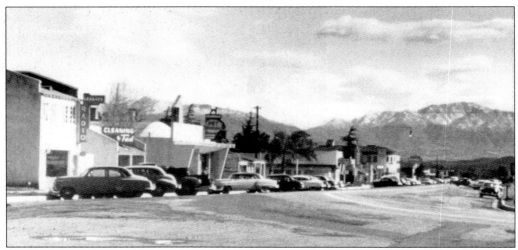

Another view of Chatsworth Street looking east from Zelzah Avenue around 1954. Longtime residents still remember when Chatsworth Street had angled parking and a distinctive "hump" that ran down the middle of the street for several blocks. (Courtesy Granada Hills Chamber of Commerce.)

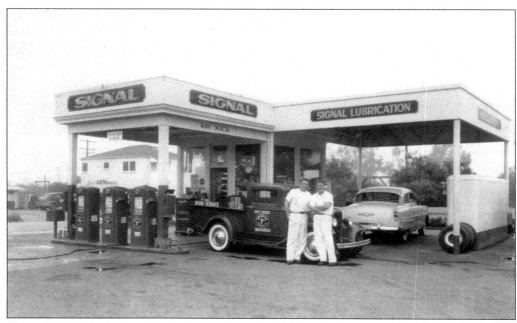

Granada Hills had no traffic lights in the early 1950s, which inspired Ray Kick's humorous advertising slogan for his Signal Oil gas station at the southwest corner of Chatsworth Street and Shoshone Avenue—"The Only Signal In Granada Hills." This photograph shows Ray (left) and attendant Jerry Reeves. (Courtesy Ray and Willa Kick.)

In the early 1950s, many of the homes in Granada Hills still had large amounts of acreage planted with orange and lemon trees from days when the Sunshine Ranch owned the property, some 25 years earlier. Here is the entrance to the Haas family residence at 10459 Zelzah Avenue (looking east on to Zelzah Avenue). Below, Susan Haas tends one of the smudge pots found in the family's orange grove. As the population of Granada Hills continued to grow, it became clear the community was going to need additional schools, including a new high school. In the late 1950s, the Los Angeles School Board decided the Haas family's property was the perfect site for a new high school—the future Granada Hills High School. It is a decision that still bothers the Haas family to this day. (Both courtesy Lorraine Haas Richardson.)

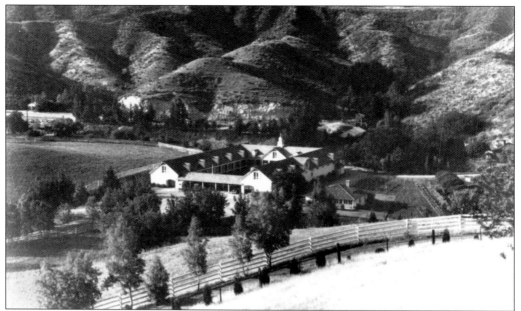

In 1939, construction began on a Thoroughbred stud farm named Rancho Oro Grande, north of the old Sunshine Ranch. The ranch was sold in 1942 to actress Janet Gaynor and her husband, Gilbert Adrian. The ranch, pictured here in the 1940s, became known as Bull Canyon Meadows according to Gaynor's son, Robin Adrian. (Photograph by Alvin Kleeb; Courtesy Richard Miseroy.)

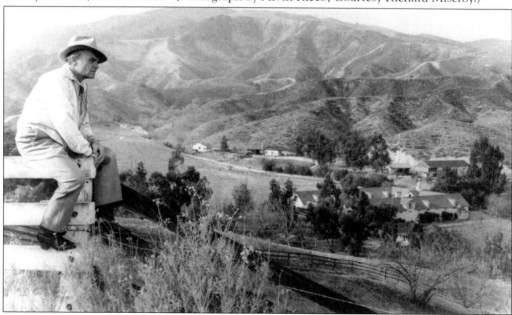

In 1953, the ranch was again sold, this time to the actor James Cagney, seen here in 1956 at the entrance to the ranch. Cagney used the ranch for raising horses but visited frequently, as did members of the Cagney family. Though the Cagneys enjoyed the ranch, they decided to sell in 1966 because of the encroachment of developers. (Photograph by Floyd McCarthy; Courtesy Richard Miseroy.)

Another actor with Granada Hills' ties was John Carroll, whose ranch was located at the southwest corner of Chatsworth Street and Hayvenhurst Avenue. Carroll and his wife, Lucille Ryman Carroll, threw lavish parties, which attracted many Hollywood stars to Granada Hills. They were also very generous to the community, making their home available for special occasions and allowing local kids to use their pool (seen here). (Courtesy Bonnie Viosca Buchanan.)

In response to growing demand for housing by World War II and Korean War veterans, Granada Hills expanded beyond its original boundaries. Aldon Construction Company, a successful San Fernando Valley builder, developed a tract of affordable three-bedroom, two-bath homes north of Chatsworth Street, between Balboa Boulevard and Hayvenhurst Avenue. In 1953, these Aldon-built homes sold for $12,000—$825 down, $59 a month! (Courtesy Roy E. Snyder Jr.)

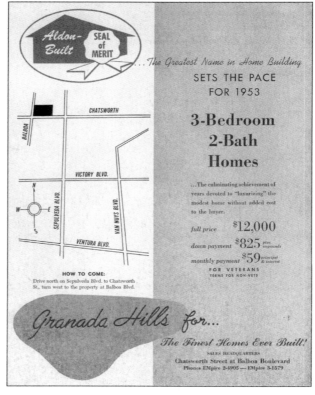

In early 1953, Roy Snyder stands on the lot of his future Aldon-built home at 16723 Tribune Street. Snyder was typical of many vets who returned from the war (in his case World War II) looking for a place to settle down and raise a family. (Courtesy Roy E. Snyder Jr.)

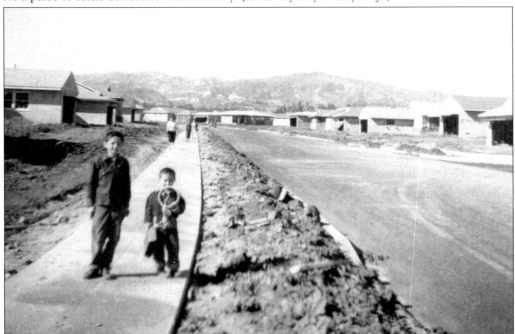

Here is another view of the Aldon-built neighborhood in 1953. Arthur Holquin and his cousin Rick Edwards are standing in front of the Holquin family's future home at 10827 Petit Avenue. To the north, Mission Point is clearly visible. (Courtesy Melinda Holquin.)

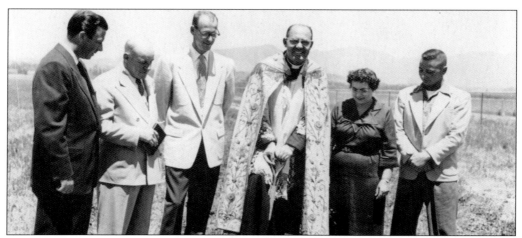

In early 1953, Card. James Francis McIntyre of the Archdiocese of Los Angeles purchased 10 acres at the northeast corner of Chatsworth Street and Hayvenhurst Avenue. On September 11 of that same year, the parish of St. John Baptist de la Salle was formally established. The first pastor was Fr. Edmund Bradley, who conducted church business out of a house purchased by the parish at 16909 Chatsworth Street. Appropriately, on March 17, 1954—St. Patrick's Day—Fr. Peter O'Sullivan (now Monsignor O'Sullivan) assumed duties as pastor for the new parish. He went to work quickly, breaking ground (above) soon after his arrival. In the fall of 1954, work on the first church was completed (below), but it became immediately apparent a larger church was needed. A new church was completed in 1967, and the old church was renamed Martinez Hall after Fr. Frederick Martinez. Father O'Sullivan became a fixture in the Granada Hills community and has remained so to this day. (Both courtesy Rev. Msgr. Peter O'Sullivan.)

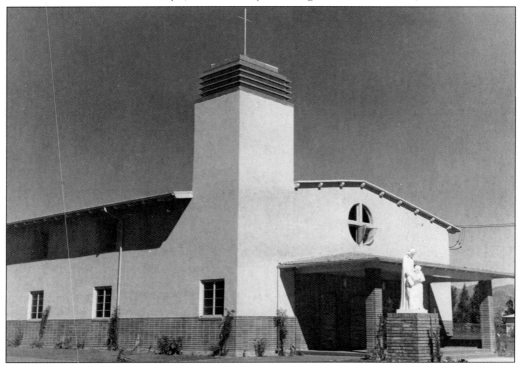

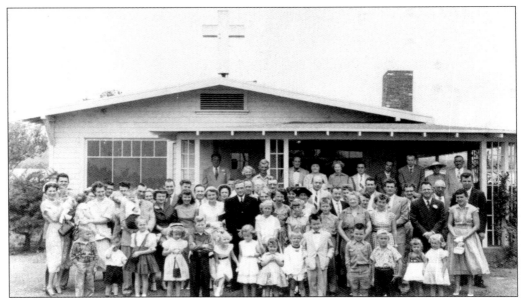

Pastor Grant Quill came to Southern California from Minnesota in June 1953 seeking a location to start a new Lutheran mission. His recommendation of Granada Hills was approved, and he returned in October 1953. A location at the northwest corner of San Fernando Mission Boulevard and Hayvenhurst Avenue was purchased, and on June 12, 1954, Our Savior's First Lutheran Church held its first services. (Courtesy Our Savior's First Lutheran Church.)

Under the leadership of Ed Harness, a Southern Baptist missionary, the First Baptist Church of Granada Hills, was organized on April 26, 1953. Services were initially held in space rented from the Granada Hills Woman's Club. In December 1953, the church, now under the direction of Pastor Willard Kelly, purchased land at 11011 Hayvenhurst Street, where they would eventually build their church. (Courtesy First Baptist Church of Granada Hills.)

Pictured here are two different perspectives on the intersection of San Fernando Mission Boulevard and Hayvenhurst Avenue around 1954. The above photograph looks east on Mission Boulevard toward the intersection with Hayvenhurst; below looks south down Hayvenhurst toward Mission Boulevard. The original building of Our Savior's First Lutheran Church of Granada Hills is seen in both. (Both courtesy Our Savior's First Lutheran Church.)

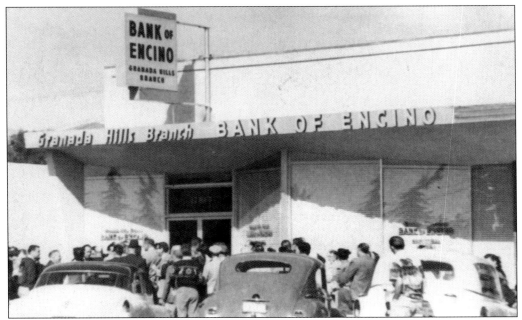

In February 1955, citizens of Granada Hills welcomed the arrival of the community's first bank, a branch of the Bank of Encino. The bank was encouraged to open an office by local businesses and community leaders. The bank was located at 17815 Chatsworth Street. (Courtesy Fred and John Weitkamp.)

Dr. Oscar Entin was an active member of Granada Hills in the 1950s and 1960s. He served as the first president of the North Valley Jewish Community Center, as well as president of the Granada Hills Rotary Club. In 1956, together with Dr. George Garabedian and Dr. Edwin Hirschtick, Entin built the Granada Hills Medical Building at 17709 Chatsworth Street. (Courtesy Cookie Entin-Kalyn.)

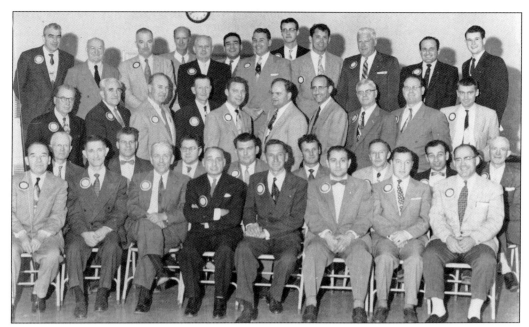

Pictured here are members of the Granada Hills Rotary Club in 1955. Thurlow Culley (third row from bottom, third from right) was instrumental in starting the Granada Hills Rotary Club in 1948 and served as its first president. (Courtesy Fred and John Weitkamp.)

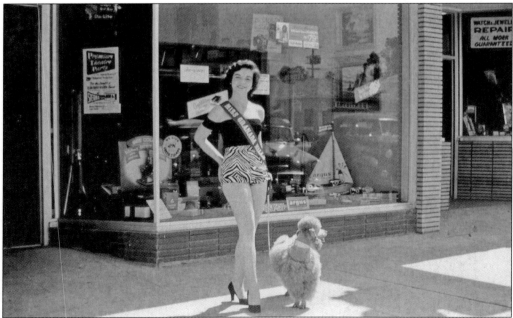

In April 1955, Granada Hills sponsored its first Miss Granada Hills pageant; the winner was Marlene Huey, posing here on Chatsworth Street. The pageant was held annually until 1992, when it was cancelled. The last Miss Granada Hills was Aimee Pelletier. Trivia experts will enjoy knowing that the town of Granada held its first beauty contest in 1936, and the winner's name was Roseanna Grossnickle. (Courtesy Marlene Huey Mattina.)

Granada Elementary reopened in 1948 after closing in 1932. Because of the postwar baby boom, a number of new schools were planned. In 1955, Tulsa Street Elementary School (10900 Hayvenhurst Avenue) became the second elementary school to serve the community. (Courtesy LAUSD Art and Artifact Collection.)

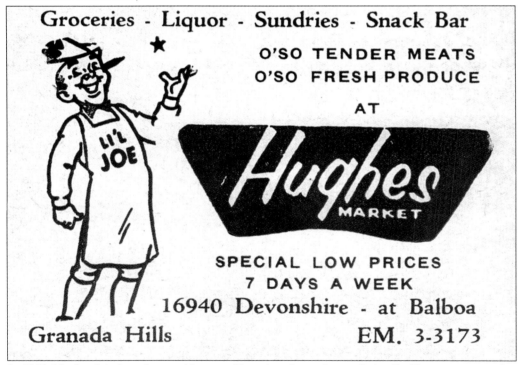

In 1955, Hughes Market, designed by noted Los Angeles architect Stiles O. Clements, opened at the North Hills Shopping Center at Devonshire Street and Balboa Boulevard. Hughes Market was the first supermarket in Granada Hills. Others would include Ralph's, Food Giant, Dale's, and Alpha Beta. Other Granada Hills architecture of note is the Richard Neutra–designed Logar Building at the southwest corner of Chatsworth Street and White Oak Avenue. (Courtesy Geraldine McGrath.)

Though established in 1928, the Granada Hills Chamber of Commerce never had an official office until 1956. Here chamber officers (from left to right) Louis M. Voivod (second vice president), Fredrick J. Weitkamp (president), and John T. Rennie Jr. (vice president) open the office for the first time. In 1958, the chamber adopted a motto for Granada Hills—"The Valley's Most Neighborly Town." (Courtesy Fred and John Weitkamp.)

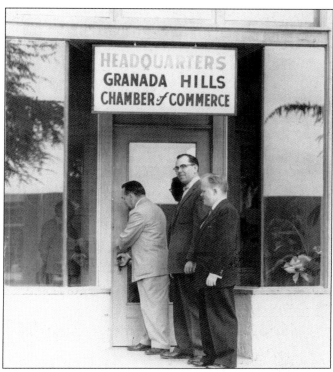

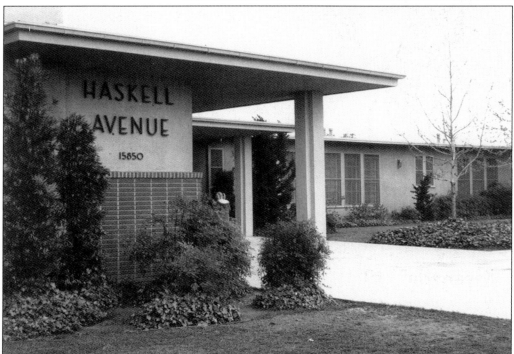

In 1956, Haskell Street Elementary School (15850 Tulsa Street) became the third public elementary school to serve Granada Hills. (Courtesy Haskell Street Elementary.)

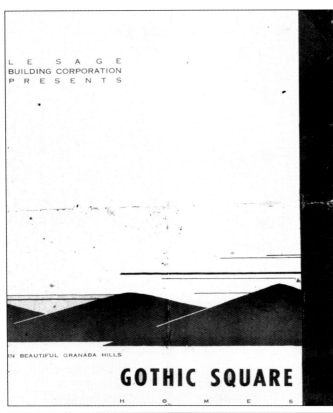

New housing projects continued to flourish through the 1950s. This is a 1957 promotional brochure for Gothic Square Homes, a small development of houses located east of Hayvenhurst Avenue, north of Index Street, west of Gothic Avenue, and south of Rinaldi Street. (Courtesy Alan Hier.)

Rev. Wes Baker started the Granada Hills Neighborhood Church (Foursquare) at 11451 Woodley Avenue on August 21, 1956. This is how the original church looked in 1959. (Courtesy Elizabeth Kipers.)

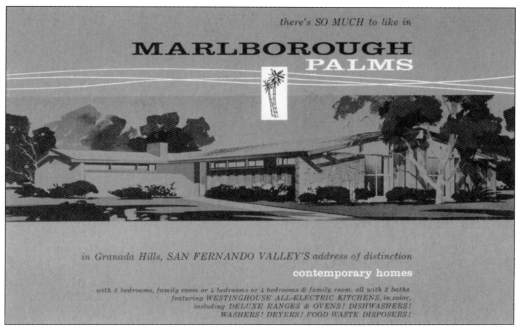

there's SO MUCH to like in

MARLBOROUGH PALMS

in Granada Hills, SAN FERNANDO VALLEY'S address of distinction

contemporary homes

with 3 bedrooms, family room or 4 bedrooms or 4 bedrooms & family room, all with 2 baths.
featuring WESTINGHOUSE ALL-ELECTRIC KITCHENS, in color,
including DELUXE RANGES & OVENS! DISHWASHERS!
WASHERS! DRYERS! FOOD WASTE DISPOSERS!

Marlborough Palms was a tract of homes designed by Southern California modernist architects Dan Palmer and William Krisel in 1957. Contemporaries of Joseph Eichler, Palmer and Krisel have gained recognition and appreciation in recent years. Interestingly, they were in Granada Hills five years before Eichler. These homes are east of Hayvenhurst Avenue, north of San Jose Street, west of Debra Avenue, and south of Chatsworth Street. (Courtesy Barry Cadish.)

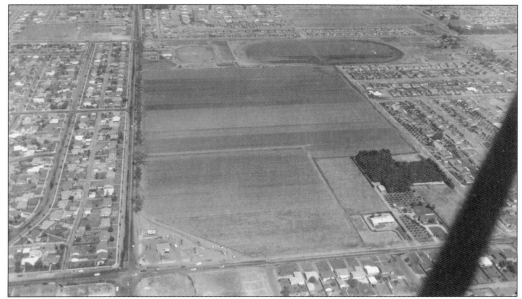

Here is the intersection of Chatsworth Street and Balboa Boulevard (c. 1957). Chatsworth runs vertically at left center of the photograph. The large empty field at the center of the image would become Petit Park. The area with the two ovals is the John Carroll Ranch (the white building). (Courtesy Los Angeles Department of Recreation and Parks.)

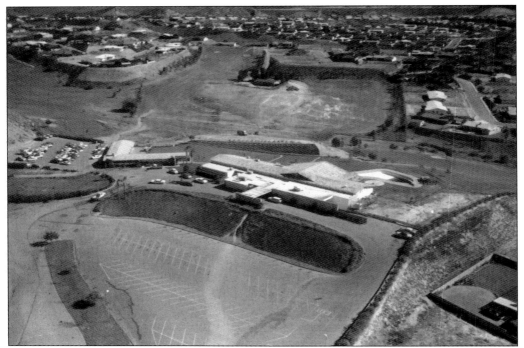

Knollwood Country Club and Golf Course, designed by renowned golf course architects Billy Bell Jr. and William Johnson, opened in late 1957. Originally a private course, within a year it was being managed by Los Angeles County, allowing public access to golfers throughout the area. (Courtesy Granada Hills Chamber of Commerce.)

At the same time plans were announced for Knollwood Golf Course, developers revealed plans for Knollwood Estates, which called for over 250 new homes to surround the course (as pictured here). Longtime resident Stanley Plog recalls that many of the streets—Sarazen, Middlecoff, Hagen, Littler, and Demaret—were named for well-known golfers. (Courtesy Pauline Sheppard.)

On November 16, 1956, the Los Angeles School Board announced plans for a new junior high school to be built in Granada Hills to relieve overcrowding of surrounding schools, principally Northridge Junior High. Initially named Granada Hills Junior High, the name was changed a month later to Patrick Henry Junior High School. On December 9, 1957, students at Northridge Junior High designated for Patrick Henry were loaded on to buses and brought to a welcoming ceremony at the new campus (above), which originally consisted of bungalows. Construction of the permanent campus (below) began in January 1959. (Above, courtesy Patrick Henry Middle School; below, courtesy LAUSD Art and Artifact Collection.)

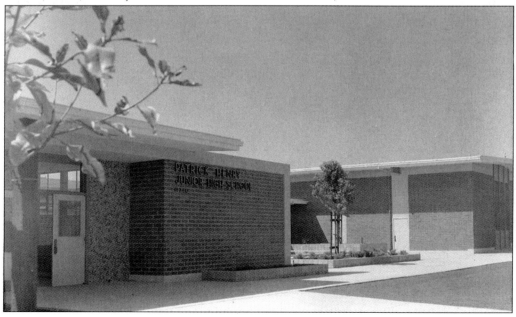

A popular community event was the Fiesta, held every year at St. John Baptist de la Salle. The carnival featured rides, games, and clowns. The area's public elementary schools also offered assorted activities and celebrations for kids, including May Day celebrations, summer playground, and Halloween carnivals. (Courtesy Jerry Shallenberger.)

Rinaldi Street Elementary (17450 Rinaldi Street) opened in 1958 and was the fourth elementary school in Granada Hills. After lengthy debate about health and safety concerns posed to children because of the proposed Simi Valley Freeway (SR-118), the school was closed in 1982. (Courtesy LAUSD Art and Artifact Collection.)

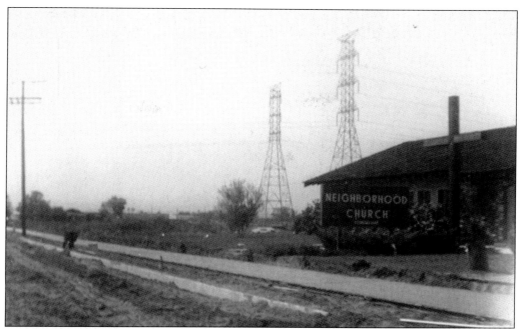

Here are two different perspectives on the section of Woodley Avenue between San Fernando Mission Boulevard and Rinaldi Street in the eastern area of Granada Hills (*c.* 1959). The above image provides a view looking south toward Mission Boulevard. The open area at the center of the photograph is where Kennedy High School would eventually be built. Below is a view north toward Rinaldi Street. Woodley Avenue can be seen climbing a hill almost totally devoid of any houses. (Both courtesy Elizabeth Kipers.)

Nikita Sergeyevich Khrushchev

ON THE OCCASION OF HIS VISIT TO THE UNITED STATES

In September 1959, at the height of the cold war between the United States and the Soviet Union, Soviet premier Nikita Khrushchev made a historic visit to the United States. On September 19, while in Los Angeles, Khrushchev asked to visit Disneyland. Concerned about security, officials instead decided to take Khrushchev on a tour of a new subdivision in Granada Hills to show him two homes on Sophia Avenue near the 16200 block of Rinaldi Street. It is still debated whether Khrushchev was angry about not being able to go to Disneyland or simply ran out of time. Whatever the reason, the motorcade, some 30 cars, simply drove past without stopping—disappointing the 300 or so people gathered to catch a glimpse of Khrushchev. Frank Dantona remembers riding his bike out to Balboa Boulevard just in time to see the procession pass by. (Courtesy author.)

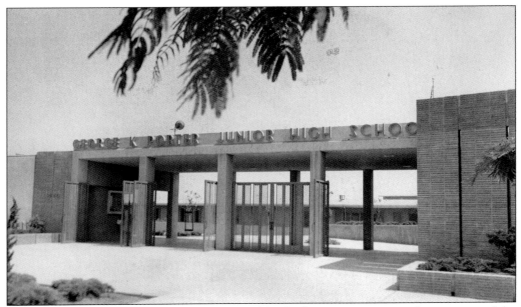

George K. Porter Junior High School was named for the former state senator who once owned the area now known as Granada Hills. Porter Junior High (15960 Kingsbury Street) was the second junior high to open in Granada Hills (1959), less then two years after the opening of Patrick Henry Junior High School. (Courtesy LAUSD Art and Artifact Collection.)

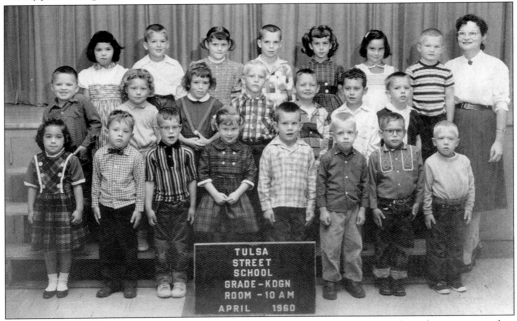

TULSA STREET SCHOOL GRADE-KDGN ROOM -10 AM APRIL 1960

As the 1950s came to a close, the growth of Granada Hills was nothing less than spectacular, growing from 5,000 people at the beginning of the decade to more than 50,000 people in 1960—a 1,000 percent population growth—one of the highest in the nation. This was due in large part to the postwar baby boom, as represented by these Tulsa Elementary kindergartners in April 1960. (Courtesy author.)

In 1960, three more schools, Danube Elementary (11220 Danube Avenue), Knollwood Elementary (11822 Gerald Avenue), and Granada Hills High School (10535 Zelzah Avenue) were opened to meet the growing number of children moving into the area. Before Granada Hills High School opened, students in Granada Hills went to San Fernando High School. Ken Morris remembers going to San Fernando High in the late 1930s; he would often hitchhike back home if he missed the school bus. During the summer months, the "Granada Kids" were often excluded from activities due to the distance to San Fernando. When it came time to name the new high school, Fred Weitkamp recalls that the school board's preference was to select the name of a former United States president—a naming tradition for new high schools. At a community meeting called for the purpose of recommending a name, Weitkamp and others were prepared. The only name offered was Granada Hills High School, and with no other suggestions, the name was approved unanimously. (Courtesy Kathy Wells.)

Pictured are, from left to right, Bryce Schurr, principal of Granada High; Peggy Whittle, girls' vice principal; and Norman Mathers, boys' vice principal, who would later become principal in the 1970s. It is somehow fitting that a community, which seemed to mirror the idealized image of suburban 1950s/1960s America, would have a high school administrator who was, in real life, the father of television's Beaver Cleaver, Jerry Mathers. (Courtesy Kathy Wells.)

Citizens of Granada Hills have always gathered to find ways to improve the community and create a positive social network. Over the years, those groups have included the Woman's Club, the 20/30 Club, the Granada Hillbillies (4H), PTA, Optimists Club, VFW, and the Granadiers (pictured here at their booth at the San Fernando Valley Fair). (Courtesy San Fernando Valley Historical Society.)

The Peter Pan Dairy at 16940 Chatsworth Street was a familiar Granada Hills landmark in the 1960s (above). In addition to the convenience of being a "drive-thru," the dairy also offered home-delivery service. A few years after opening in 1961, Peter Pan was joined around the corner on Balboa Boulevard by, appropriately enough, Tinkerbell Cleaners (below). (Above, courtesy Bob Schoenkopf; below, courtesy Granada Hills Chamber of Commerce.)

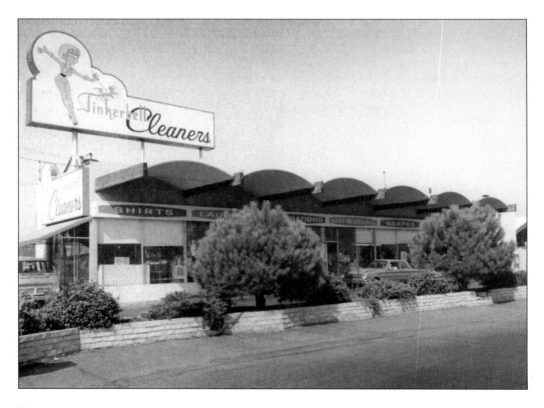

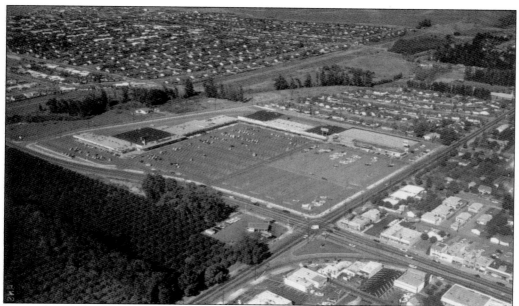

These photographs show two major shopping centers established in Granada Hills in 1961. Above is Granada Village Center (northwest corner of Chatsworth Street and Zelzah Avenue) on land formerly owned by Otto Baty. Memorable stores here include Thriftymart, Carvel's, Mama Lucia's, Thrifty Drugs, and Granada Lanes. The LAPD also established their Devonshire Division station here before moving to Devonshire Street and Lindley Avenue. The stand of trees to the left is where the Treasury department store would eventually be built. Below is a view looking south toward the intersection of San Fernando Mission and Balboa Boulevard. Just beyond the two groves of trees (that would eventually become Gemco and Builders Emporium) is the Balboa Mission Shopping Center, originally home to Food Giant, J. J. Newbury's, Winchell's, and Perky Party. (Both courtesy Granada Hills Chamber of Commerce.)

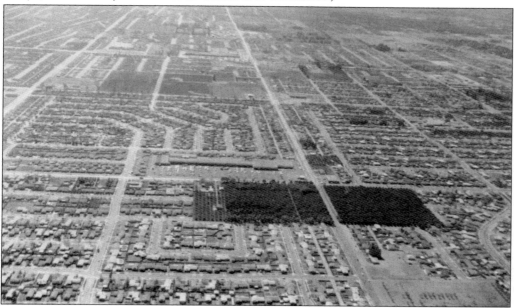

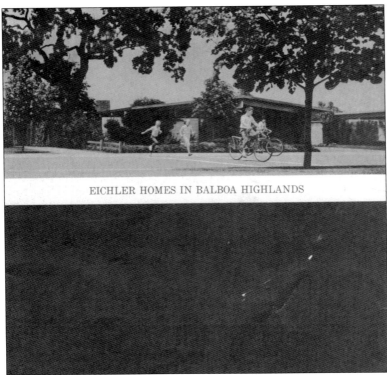

EICHLER HOMES IN BALBOA HIGHLANDS

Joseph Eichler was a real estate developer best known for building homes in the modernist style. Eichler's homes are primarily found in Northern California, but in 1962, Granada Hills became one of three Southern California communities with an Eichler development. Known as Balboa Highlands, Eichler originally planned to build almost 300 homes in Granada Hills but scaled back to fund other projects. (Courtesy Anne Ziliak.)

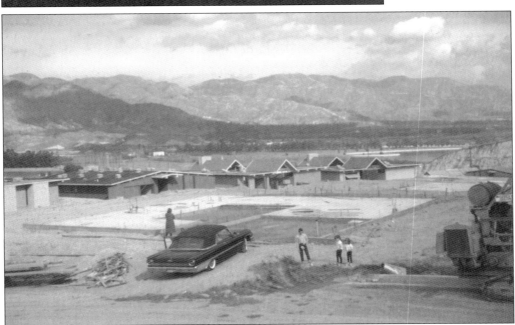

Granada Hills' tract of some 100 Eichler homes can be found on Darla Avenue, Lisette Street, Nanette Street, and Jimeno Avenue. The site planners and principle architects for Balboa Highlands were A. Quincy Jones and Frederick Emmons. Here is a home in the 12700 block of Darla Avenue under construction in 1964. (Courtesy Marti McInnis.)

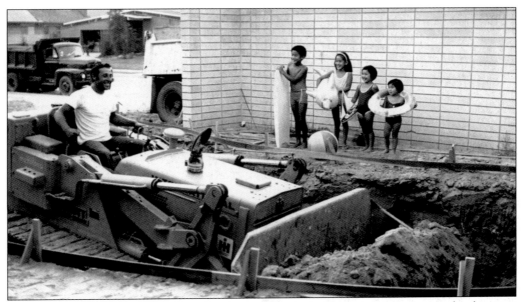

Eichlers are known for their modernist style, quality post and beam construction, and welcoming atriums. Joseph Eichler was also an early advocate of equal housing practices. In a time when housing discrimination was common, Eichler would sell homes to anyone regardless of race or religion. In 1958, he resigned from the National Association of Home Builders because of their refusal to support a nondiscrimination policy. Pictured above from left to right, the Yamashiro children, Ron, Susan, Jill, and Lee, are eager to swim in the pool being built in the front atrium of their 17078 Lisette Street Eichler. Below is the back of another Lisette Street home with the post and beam construction, which, according to longtime Eichler resident Bernie Grossman, allowed Eichlers to survive recent earthquakes virtually intact. (Above, courtesy Susan Yamashiro Milner; below, courtesy Anne Ziliak.)

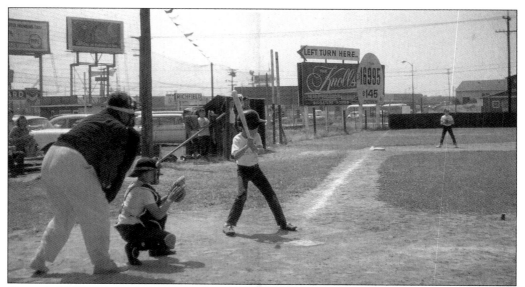

Granada Hills' first Little League ballpark, Tobias Field, was located at the northwest corner of Devonshire Street and Balboa Boulevard in the early 1960s. The field was later moved to Rinaldi Street, below the Van Norman Dam. Note the billboard for homes in the Knollwood area of Granada Hills. (Courtesy Richard H. Pena.)

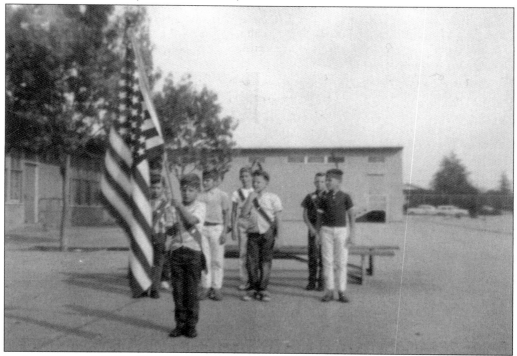

In the 1950s and 1960s, Granada Hills' baby boomers took part in a number of youth-oriented activities. In addition to Boy and Girl Scout programs, kids could join Indian Guides, Camp Fire Girls, Bluebirds, and Woodcraft Rangers, pictured here at Tulsa Street Elementary. (Photograph by Ann Hier; courtesy author.)

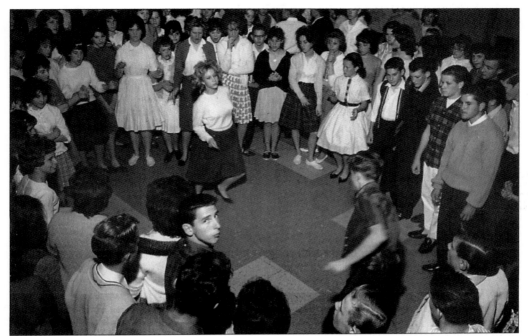

The 1960s ushered in an era of considerable social change across the United States. New standards of dress, hairstyles, and even dance (like this one at Porter Junior High) challenged established social norms. Students during this time often recall school administrators who had rulers in hand to measure hemlines or who would threaten suspension for an "inappropriate" hairstyle. (Courtesy LAUSD Art and Artifact Collection.)

Located at 12230 El Oro Way, El Oro Way Elementary opened in 1962, the seventh public elementary school to serve Granada Hills. (Courtesy LAUSD Art and Artifact Collection.)

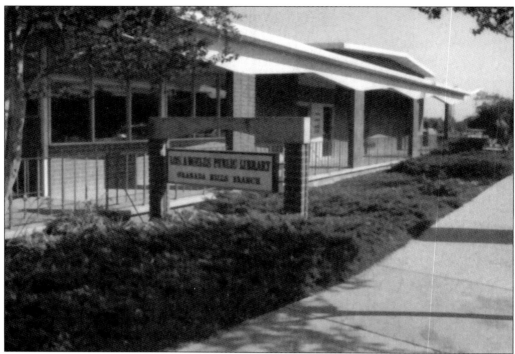

In the 1930s, local volunteers ran Granada Hills' first library out of the Granada Building. In the 1950s and early 1960s, the Los Angeles Public Library's bookmobile made regular stops. A bond measure to build a library in Granada Hills was passed in 1957, and in November 1962, Los Angeles mayor Sam Yorty officially opened the new $231,000 facility seen above. The library is located at the southeast corner of Chatsworth Street and Petit Avenue. The much-anticipated opening was well attended by a community anxious to access the 20,000 volumes housed in the new library. Included in the awaiting crowd was the future author of this book, seen below, at far left with his back to the camera—standing where he shouldn't be! (Above, courtesy Granada Hills Chamber of Commerce; below, courtesy author.)

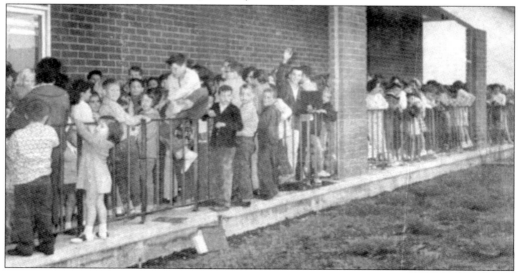

On July 21, 1963, the Granada Hills Recreation Center was officially dedicated. In the years to come, it would include a public pool, tennis courts, and a band shell. Originally known as Petit Park, it is now officially called the Granada Hills Recreation Center. (Courtesy Los Angeles Department of Recreation and Parks.)

School paper drives, like this one at Haskell Street Elementary, were a common site in Granada Hills in the 1960s and a popular way for schools to raise extra money for student activities. (Courtesy Haskell Street Elementary.)

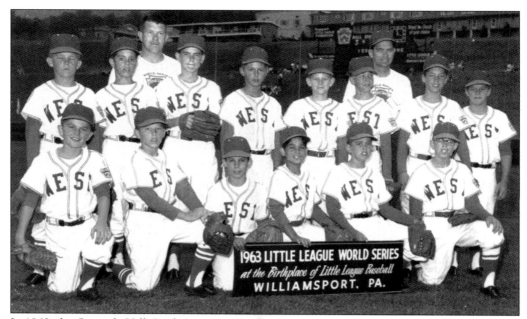

In 1963, the Granada Hills Little League All Star team put a national spotlight on Granada Hills. Members of the team pictured here from left to right after their Western Regional victory are as follows: (first row) Rob Vaughn, Tom Berry, Jim Walker, Tom Orlando, Mike Shara, and Wayne Kennedy; (second row) Dave Nagel, Dave Bees, Dave Sehnem, Fred Siebly, Gary Anderson, Steve Schulz, Mark Christensen, and Ken Kinsman; (third row) manager Glen Berry and coach Bill Sehnem. (Courtesy Dave Sehnem.)

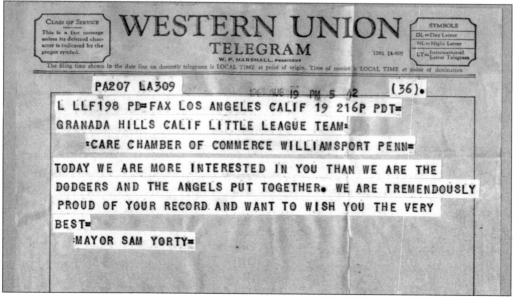

After winning the Western Regionals, the team went to Westport, Pennsylvania, to participate in the Little League World Series playoffs. As the team continued to win, local interest in the boys reached a fevered pitch, as this telegram to the team from Los Angeles mayor Sam Yorty attests. (Courtesy Geraldine Berry.)

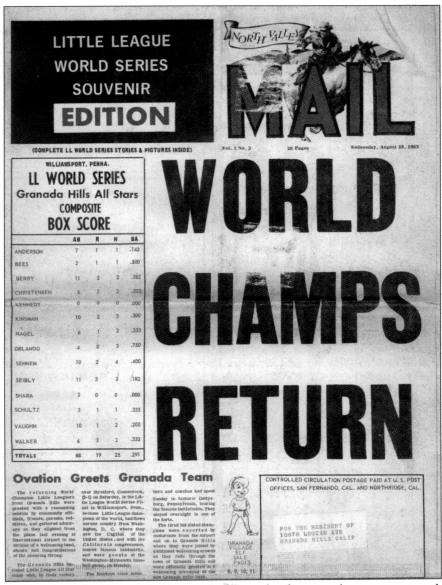

WILLIAMSPORT, PENNA.
LL WORLD SERIES
Granada Hills All Stars
COMPOSITE
BOX SCORE

	AB	R	H	BA
ANDERSON	7	1	1	.143
BEES	2	1	1	.500
BERRY	11	2	2	.182
CHRISTENSEN	6	2	2	.333
KENNEDY	0	0	0	.000
KINSMAN	10	2	3	.300
NAGEL	6	1	2	.333
ORLANDO	4	0	3	.750
SEHNEM	10	2	4	.400
SEIBLY	11	3	2	.182
SHARA	2	0	0	.000
SCHULTZ	3	1	1	.333
VAUGHN	10	1	2	.200
WALKER	6	3	2	.333
TOTALS	88	19	25	.291

Ovation Greets Granada Team

The returning World Champion Little Leaguers from Granada Hills were greeted with a resounding ovation by community officials, friends, parents, relatives, and gathered admirers as they alighted from the plane last evening at International Airport to the strains of a welcoming band, shouts and congratulations of the cheering throng.

The Granada Hills National Little League All Star team who, by their victory over Stratford, Connecticut, (2-1) on Saturday, in the Little League World Series Final in Williamsport, Penn., became Little League champions of the world, had flown across country from Washington, D. C. where they saw the Capitol of the United States, met with the California congressmen, toured famous landmarks, and were guests at the Washington-Minnesota baseball game, on Monday.

The fourteen team members and coaches had spent Sunday in historic Gettysburg, Pennsylvania, touring the famous battlefields. They stayed overnight in one of the forts.

The tired but elated champions were escorted by motorcade from the airport and on to Granada Hills where they were joined by additional welcoming crowds as they rode through the town of Granada Hills and were officially greeted at a welcoming ceremony at the new Granada Hills Park.

GRANADA
VILLAGE
ELF
SALE
PAGES
8, 9, 10, 11

On August 24, 1963, the Granada Hills team made it to the championship game against the team from Stratford, Connecticut. In a dramatic effort, Dave Sehnem led his team to a 2-1 victory. ABC's *Wide World of Sports* broadcasted the World Series championship game for the very first time in the history of the Little League. On their return home, the boys were paraded down Chatsworth Street to the cheers of hundreds of people who turned out to celebrate their victory. Sehnem was invited to throw out the opening pitch at Dodger Stadium during the Dodgers' own march to the Major League World Series playoffs. After the Dodgers won the National League Pennant, Granada Hills' other pitcher, Tom Berry, was invited to throw out the opening pitch at the first game of the 1963 Major League World Series. For months after their victory, the boys and the team were honored, and the community used their win to raise money for a new ballpark and youth sports center off Rinaldi Street on land owned by the Los Angles Department of Water and Power. The new center was dedicated in 1965. (Courtesy Geraldine McGrath.)

St. Stephen's Lutheran Church (15950 Chatsworth Street) was established in 1955 during the time of Granada Hills' rapid population growth. In 1963, the church sponsored the creation of Roger Darricarrere's stained-glass masterpiece *Christ, The Light of the World*. The window was displayed at the New York World's Fair from 1964 to 1965. In 1966, it was brought to Granada Hills and installed at St. Stephen's. (Courtesy Kathy Baker Lindgreen.)

The Granada Hills Community Hospital (10445 Balboa Boulevard) opened in 1966. Part of the hospital was built on the site of the old Little League baseball field. Over the years, the hospital gradually expanded, improving the quality of service and care provided to the community. Beset by financial problems, the facility closed in 2003. (Courtesy Sharon Klek.)

In early 1963, ten years after establishing the parish of St. John Baptist de la Salle, Card. James Francis McIntyre of the Archdiocese of Los Angeles saw the need for a second parish to serve Granada Hills. The first masses for the St. Euphrasia Catholic Church were offered at Knollwood Country Club and then moved to El Oro Way Elementary until the new church was built. On November 21, 1965, on land once occupied by the old Sunshine Ranch, ground was broken. The construction area of the new church at the corner of Mayerling Street and Shoshone Avenue (looking south) is visible above. First masses were offered in the new church on October 23, 1966. Cardinal McIntyre formally dedicated the church in spring 1968 (below). (Both courtesy St. Euphrasia Catholic Church.)

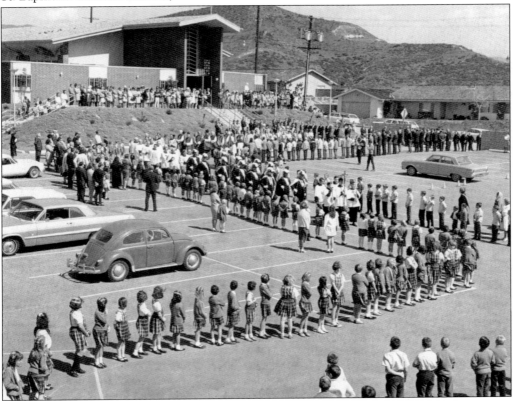

In 1966, two Granada Hills' landmarks met very different fates. The Cultural Heritage Board of Los Angeles declared the 144 deodar trees planted by Sunshine Ranch's John Orcutt in the early 1930s as a historic cultural monument (above). The trees lined both sides of White Oak Avenue between San Jose Street and San Fernando Mission Boulevard. White Oak Avenue and the deodars achieved a new kind of recognition in 1982, when the street and the trees served as the backdrop for the movie *ET: the Extra-Terrestrial*. The old Granada Building that was once home to the Char-Mar Malt and Coffee Shop, after years of neglect, was completely renovated to make way for the Chatoak Pet Clinic (below). The renovation included removal of the second story of the original building. (Above, courtesy Sharon Klek; below, courtesy Fred and John Weitkamp.)

As early as 1964, the California Division of Highways was looking for the best route to build the proposed Simi Valley Freeway (SR-118). Four routes were recommended, three of which would cut through Granada Hills. The debate that ensued lasted for years and was one that would physically and emotionally divide the citizens of Granada Hills. The freeway was later renamed to honor former president Ronald Reagan. (Courtesy author.)

Route 118 In The San Fernando Valley...

SIMI VALLEY Freeway

Every time it snows in Granada Hills it's memorable, especially since it only seems to happen about every 20 years. In April 1967, it happened again, producing enough of the white stuff to build a snowman, but apparently not enough leftover for a decent snow angel. Members of the Petit Avenue Holquin and Culver families pose with their wintry creation. (Courtesy Melinda Holquin.)

97

In 1965, Robert Sforzini, Phillip Dye, and the Granada Hills Rotary Club, under the leadership of Dr. Oscar Entin, proposed a community music center for Granada Hills in the new Petit Park. On June 1970, the band shell was dedicated, though the final structure fell far short of the original vision. The structure was badly damaged in the 1994 Northridge earthquake and subsequently was torn down. (Photograph by Ann Hier; courtesy Laura Crite.)

Less than two months before 1969's Woodstock, a different kind of music than envisioned by Granada Hills' Rotary Club rocked Granada Hills. Newport 69, a three-day festival at Devonshire Downs (on Granada Hills' southern border), featured Jimi Hendrix. Other acts included Creedence Clearwater Revival, Joe Cocker, Jethro Tull, and Ike and Tina Turner. The concert could be easily heard at Granada High's graduation ceremony that Friday evening. (Courtesy Lance Blakeslee.)

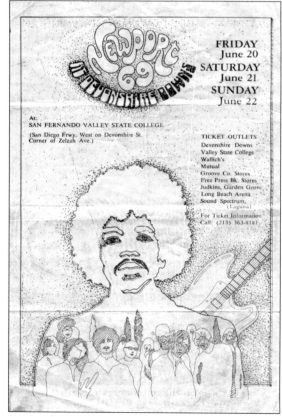

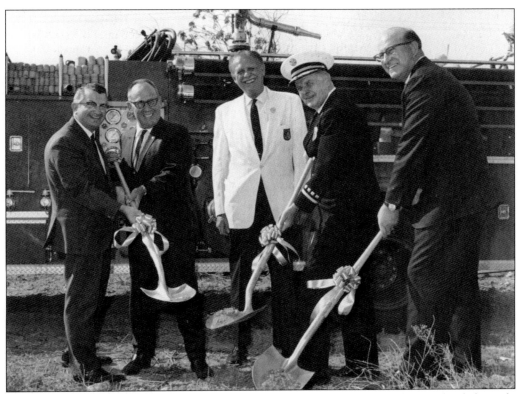

Ground was broken for the second fire station to serve the Granada Hills area (and the only one within the "modern" boundary of Granada Hills) on October 20, 1967, on land adjacent to the Knollwood Country Club. From left to right are Walter E. Adolphson, Lee Hamer, Frank R. Wilcox, Raymond M. Hill, and Louis R. Nowell. (Courtesy Los Angeles Fire Department, Fire Station No. 18.)

As early as 1966, it was clear Granada Hills would need a second high school. In 1968, funds were approved to purchase more than 60 homes in order to build the new John F. Kennedy High School, including the home of Alexander and Clara Marie Shutz (seen here). Interestingly, Kennedy High School ended up sharing the same address as the Shutz family's former home—11254 Gothic Avenue. (Courtesy Susanna Shutz Robar.)

Van Gogh Elementary School (17160 Van Gogh Street), Granada Hills' eighth elementary school, opened in 1968 and has the distinction of being Granada Hills' newest elementary school on two separate occasions—thanks to the 1994 Northridge earthquake. (Courtesy Van Gogh Elementary School.)

IT'S NOT ENOUGH TO SAVE THE WORLD

WE MUST MAKE THE WORLD WORTH SAVING

CORINTIANS

robert frost junior high 1972

Construction on Robert Frost Junior High, Granada Hills' third junior high school, located at 12314 Bradford Place, began in 1967, and the school opened in 1969. This is a graduation program from the 1972 graduating class. (Courtesy Bob Hier.)

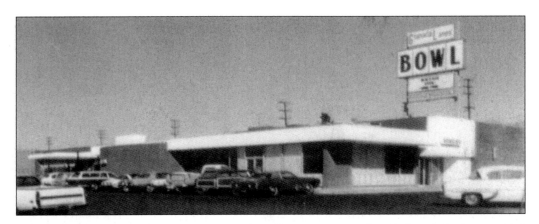

Like most communities, residents of Granada Hills were interested in finding fun ways to spend time with friends and family. Granada Lanes, the local bowling alley, was located in the Granada Village Center (Chatsworth Street and Zelzah Avenue). With 48 lanes, it was a popular destination for young and old alike. Opened in the early 1960s, Granada Lanes remained a community fixture until 1994. Located in the same shopping center, but for only a couple of years in the late 1960s, was an attraction known to the local kids as simply "The Big Slide." For about a quarter, kids were given a burlap sack to sit on, a warning to hold on tight, and a lifetime to remember the lightning fast downhill ride. (Both courtesy Sharon Klek.)

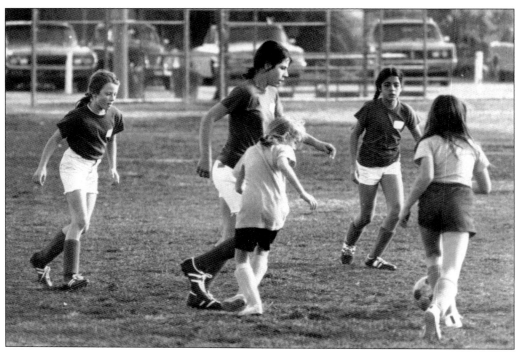

In 1969, Granada Hills resident Joe Karbus noticed young girls becoming bored at their brother's Petit Park soccer games. Soon he found himself organizing teams and recruiting local broadcaster (and soccer enthusiast) Mario Machado to help coach. Joe then worked to gain official sanction from the American Youth Soccer Organization (AYSO) for the nation's first all-girls soccer league. As a result of Karbus's efforts, Granada Hills became the birthplace of the phenomenon known as girls' soccer. (Courtesy Joe Karbus.)

Warren M. Dorn
Supervisor, Fifth District

and

Norman S. Johnson, Director
County Parks and Recreation

in cooperation with
General Omar N. Bradley and Bob Hope

Cordially invite you and your friends

to join us at the Tenth Hole

for the Dedication of Knollwood

County Golf Course to the Memory of

President
Dwight David Eisenhower

and

to preview County Plans for the Clubhouse as
projected by the Board of Supervisors

Monday, March 30, 1970

1:30 p.m.

12040 Balboa Boulevard
Granada Hills

In January 1970, following the death of Pres. Dwight Eisenhower, the Los Angeles Board of Supervisors agreed to rename Knollwood Golf Course after the former president. The community objected, in large part because there had been no consultation before approving the plan. The objections worked, because by March 1970, the supervisors decided simply to dedicate the course in Eisenhower's memory. (Courtesy Granada Hills Branch, Los Angeles Public Library.)

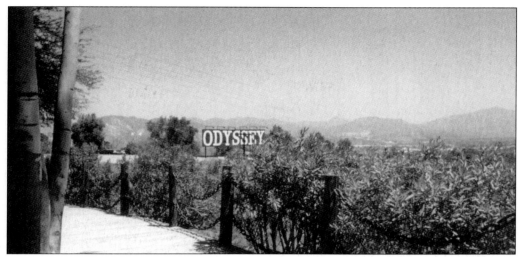

In 1970, the Odyssey Restaurant opened at the eastern edge of Granada Hills on one of the enchanted hills seen in the early photographs of the San Fernando Mission. On a clear day, the restaurant offers a wonderful view of the San Fernando Valley and Granada Hills. (Courtesy Sharon Klek.)

The future principal of John F. Kennedy High School, William Albers, takes in a different view as he oversees construction of Granada Hills' newest school. Ground-breaking ceremonies for the school took place in March 1969. Following the assassination of Martin Luther King in 1968, there had been an unsuccessful effort to have the new school named for Dr. King. (Courtesy William R. Albers.)

FOOTBALL SCHEDULE

far out—2nd in Valley

PRACTICE GAMES

Thurs., Sept. 24—Jefferson at GH

Won B Game Only—3:00 p.m.

Sat., Sept. 26—GH at Western

Won High, Las Vegas

Varsity Game Only—8:00 p.m.

Fri., Oct. 2—Los Angeles at GH

Varsity-8:00 p.m.—B-5:30 p.m.

won

MILK BOWL *LOST*

Fri., Oct. 9—GH vs. Carson

won at El Camino Junior College

LEAGUE GAMES

Fri., Oct. 16—Monroe at GH *won*

Fri., Oct. 23—GH at Van Nuys *won*

Fri., Oct. 30—Poly at GH *won*

Fri., Nov. 6—Birmingham at GH *Wo*

Fri., Nov. 13—GH at San Fernando *LOST*

Varsity-8:00 p.m.—B-5:30 p.m.

Playoffs: Nov. 21, Nov. 28, Dec. 5, Dec. 12 *won won won*

in all city

As 1970 ended, Granada Hills was treated to what many consider one of the greatest high school football games in Southern California history—the 1970 city championship game that pitted Granada Hills High against rival San Fernando High. The Granada team had enjoyed a spectacular season; their only league loss was to San Fernando a month earlier, as noted on the pocket schedule carefully annotated by 10th-grader Sue Evans. On December 12, 1970, the stage was set for a rematch and the city championship. Before a record crowd of nearly 18,000 fans, the game was played at Birmingham High School in Van Nuys. Quarterback Dana Potter led the Highlanders; Anthony Davis commanded the Tigers. It was a hard-fought game, but when the dust settled, Granada Hills was victorious. Their 38-28 win allowed them to claim the title of city champions. (Courtesy Susan Evans Handley.)

Six

BETWEEN THE EARTHQUAKES
1971–1994

The year 1971 started on a high note for Granada Hills. With the city championship victory still fresh in people's minds, residents settled in on New Year's morning to watch the Pasadena Rose Parade as the Granada Hills High School Highlander Marching Band marched down Pasadena's Colorado Boulevard. The marching band, here in a local Granada Hills parade, was a perennial Rose Parade favorite. (Courtesy Granada Hills Chamber of Commerce.)

At 6:01 a.m. on February 9, 1971, the 6.6-magnitude Sylmar earthquake rocked Granada Hills. Many residents were just getting ready for work or school; some were still sleeping. Many remember in the moments before the quake, their dog, or the neighbor's, barking wildly for no apparent reason. Others simply recall the sound of breaking glass. As soon it was safe, residents began assessing the damage. For the most part, Granada Hills' homes were not too badly affected. Kitchens were generally a mess, with a weird mix of broken glass and various food and liquids mixed together on the floor. Lamps were toppled over, pictures were knocked askew, and a few cracks formed in the plaster. Outside, cinder block walls had toppled and maybe the occasional chimney—all in all, not too bad. (Above, courtesy Stanley Plog; below, courtesy Jerry Wojcik.)

Granada Hills businesses fared reasonably well, though there were some notable exceptions. The library sustained some damage, as seen at right, but clearly the worst was the Thrifty Drug Store at Granada Village Center (Chatsworth Street and Zelzah Avenue). A broken gas main ignited, and the store was a total loss (below). Other nearby communities were not as fortunate as Granada Hills. Sections of Olive View and the Veterans Administration Hospital collapsed, accounting for most of the fatalities that morning. Homes and businesses in Sylmar and San Fernando were shaken from their foundation, and many were destroyed. The freeways surrounding Granada Hills also sustained a significant amount of damage. (Above, courtesy Granada Hills Branch, Los Angeles Public Library; below, courtesy Dietmar Kuehn.)

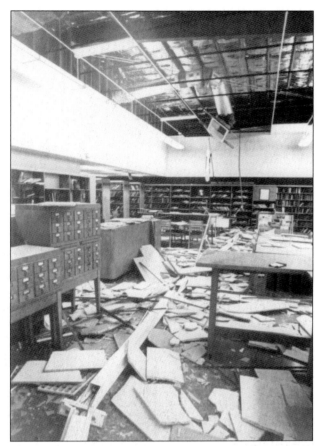

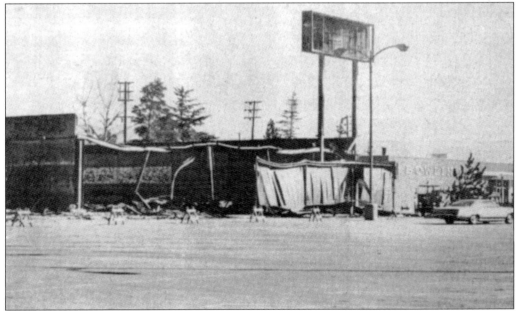

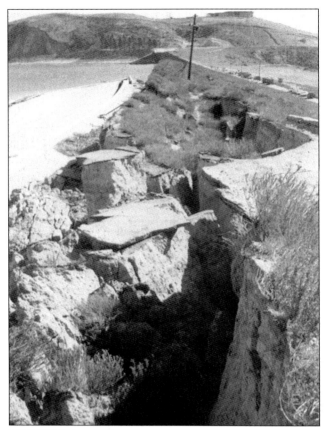

However, within an hour, Granada Hills' citizens realized they may not have been as lucky as first thought. A 60-foot section of the Van Norman Dam had crumbled (left). Fearing the dam could break and send six billion gallons of water across Granada Hills and the valley, authorities ordered the immediate evacuation of nearly 80,000 people, including virtually half of Granada Hills. Helicopters flew overhead, advising residents to leave as quickly as possible. Evacuation centers were set up throughout the valley, including at Frost Junior High and Granada Hills High School. As concerns lessened, officials scaled back the evacuation, but it was nearly a week before many Granada Hills residents could return home. Days after water had been released from the dam, the full extent of the damage became clear (below). (Above, courtesy Los Angeles Department of Water and Power; below, courtesy Stanley Plog.)

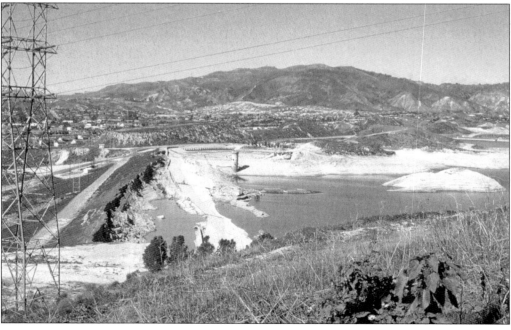

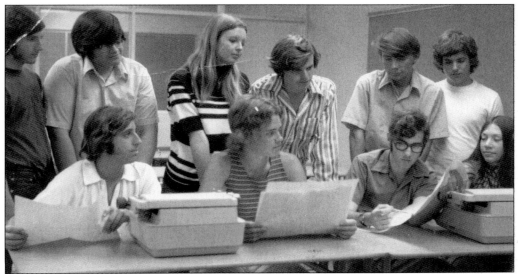

During the summer of 1971, students slated to attend the new John F. Kennedy High School gathered at neighboring Granada Hills and Monroe High Schools to organize extra-curricular programs, such as football, drill team, student government, and journalism. Members of the original journalism staff are, from left to right, as follows: (first row) Richard Agata, Matthew Van Benschoten, Wayne Miller, and Joyce Gould; (second row) David Zaslawsky, Lance Blakeslee, April Strong, Jim Hier, Tom Handley, and Gary Sparage. (Courtesy John Koerber.)

On September 14, 1971, John F. Kennedy High School, Granada Hills' second high school, opened its doors to 2,100 tenth- and eleventh-grade students; Los Angeles Unified School District opted not to have a senior class the school's first year. The opening of Kennedy provided relief to an overcrowded Granada Hills High, which had one of the largest school populations in the nation the previous school year. (Courtesy John Koerber.)

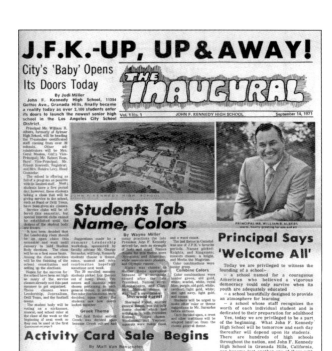

On the first day of classes at John F. Kennedy High School, students were welcomed with a four-page school newspaper appropriately named the *Inaugural* (later renamed the *Word*). Kennedy's journalism program was led by teacher/advisor Jerry Weiner. By the end of Kennedy's first year, the journalism program was one of the largest in California with approximately 10 percent of the student body involved in some way. (Courtesy Students of A307.)

It took a while for Kennedy's football program to establish itself (they lost every game the first season), but that still did not stop kids from coming out and cheering for the home team. However, there may have been another reason for the crowds—the Kennedy High Drill Team. The drill team was an immediate hit and quickly became "ambassadors" of the high school throughout the community. (Courtesy author.)

In the 1960s and 1970s, it was not uncommon to go to the International House of Pancakes on Devonshire Boulevard and see large groups of high school kids in their pajamas enjoying an early morning breakfast—the result of a successfully orchestrated "Kidnap Breakfast." In this 1972 photograph, Kennedy High journalism girls have been "kidnapped" (with their parents' permission) by the journalism boys. (Courtesy John Koerber.)

Granada Hills has always loved a parade. In 1973, they started a new tradition, the annual Youth In Action Parade, which was sponsored by the Granada Hills Chamber of Commerce. The parade featured marching bands and drill teams from schools throughout Southern California, as well as a wide array of youth and community groups. (Courtesy Sharon Klek.)

In 1973, the City of Los Angeles agreed to purchase John O'Melveny's C and J Ranch, which created the largest city owned park, second only to Griffith Park. Originally named Bee Canyon Park, the name was changed in 1976 to honor O'Melveny's contributions to Los Angeles. In 1979, councilman Bob Wilkinson held a ground-breaking ceremony to mark the initial phase of development to the park. (Courtesy Van Gogh Elementary.)

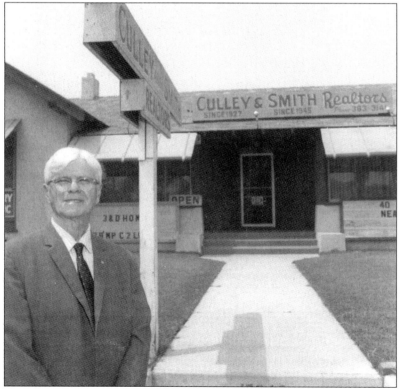

Thurlow Stather Culley stands in front of the office he maintained since coming to Granada in 1927. Granada Hills marked its 50th anniversary in the 1970s, and Culley remained an active part of the community for each of those 50 years, playing a vital role in making Granada Hills the community it is today. Culley passed away in 1980. (Courtesy Carolyn Culley Clark.)

After years of debate about where to build the Simi Valley Freeway, transportation officials, city planners, and citizens finally agreed on the northernmost route, bypassing the oldest part of Granada Hills. When building started, houses in the path of the freeway were relocated or leveled, leaving whole sections of Granada Hills with vacant lots (above). To mark the freeway's completion in December 1982, officials invited local kids to ride their bicycles on the new freeway—before opening it for regular use (below). After the freeway opened, the Granada Hills Chamber of Commerce, under the leadership of John Ciccarelli and John Weitkamp, successfully petitioned Caltrans in 1985 to install an exit sign for Granada Hills, ensuring the community would not be bypassed or overlooked. (Above, courtesy Dave Weiland; below, courtesy "Uncle" Don Fanning.)

Service, Community, Experience...

The Bank of Granada Hills

In 1983, a group of local citizens formed the Bank of Granada Hills at 10820 Zelzah Avenue to cater to the special needs of local businesses. Perhaps best known for its distinctive Tudor architecture, the bank has served as the backdrop in numerous Hollywood productions, including *Knott's Landing*, which featured a number of Granada Hills locations. The bank changed its name to First State Bank in 2001. (Courtesy Sharon Klek.)

In 1984, the Granada Hills Chamber of Commerce revamped the Youth In Action parade. The result was the Granada Hills Holiday Parade, held every year on the first Sunday of December. The parade has become a highly anticipated and much-loved community event. Longtime Granada Hills resident John Ciccarelli has been responsible for organizing the parade every year since 1984. (Courtesy Granada Hills Chamber of Commerce.)

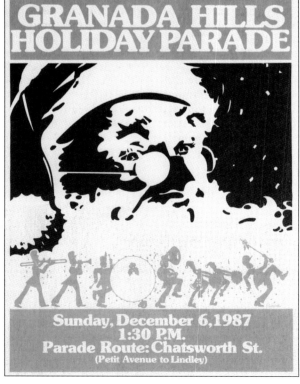

GRANADA HILLS HOLIDAY PARADE

Sunday, December 6, 1987
1:30 P.M.
Parade Route: Chatsworth St.
(Petit Avenue to Lindley)

114

In the 1980s, many buildings associated with Granada Hills' past changed or disappeared. Some old Edwards and Wildey homes proved too small for modern needs. Houses were renovated, expanded, or torn down. Here are two buildings that are now gone. The main ranch house of the Sunshine Ranch is seen as it appeared in the early 1980s (above). The house was eventually torn down to make way for a Hillcrest Christian School expansion. Today three bunkhouses on the west side of Shoshone Avenue, north of Rinaldi Street, are all that remains of the Sunshine Ranch. Below is Jimmy Cagney's Bull Canyon Meadows stable in 1986. The stable was torn down in 1988 to make way for a new development. (Above, courtesy Granada Hills Chamber of Commerce; below, courtesy Richard Miseroy.)

In 1984, a seven-screen movie theater was built at Granada Village Center (Chatsworth Street and Zelzah Avenue). At the time, United Artists billed the movie theater as the first ever built in Granada Hills, apparently unaware of the old Granada movie theater that opened at the northwest corner of San Fernando Mission Boulevard and Woodley Avenue in 1963. (Courtesy Sharon Klek.)

In 1966, one of the last remaining orange groves in Granada Hills, at the northwest corner of San Fernando Mission Boulevard and Balboa Boulevard, was removed to make room for the new Gemco department store. Gemco closed its doors in 1986, and a Target department store reopened on the same site. In 2007, this building was torn down to make way for a new, two-story Target store. (Courtesy Sharon Klek.)

On February 8, 1989, 40 years after the 1949 snowstorm, Granada Hills was again treated to a rare dusting of snow. This time, however, it only lasted for a day, long enough for people to snap a few pictures. Sharon Klek captured the image at right along White Oak Avenue. Below, Norbert Weiland stands in front of the house he built at Tulsa Street and Collette Avenue around the time of the 1949 storm. (At right, courtesy Sharon Klek; below, courtesy Dave Weiland.)

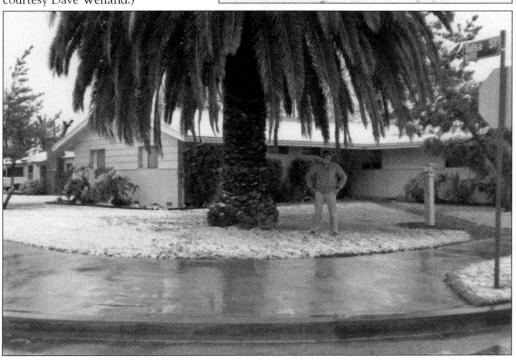

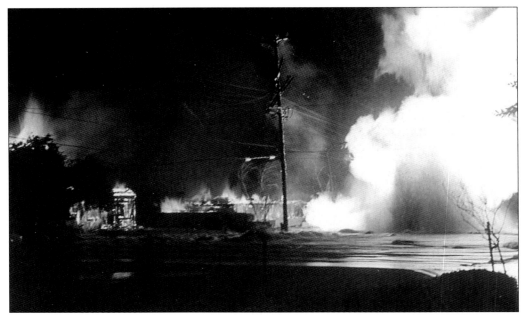

On January 17, 1994, the relative calm that had come over Granada Hills since the Sylmar earthquake 23 years earlier was abruptly broken at 4:31 a.m. What has become known as the Northridge earthquake shook Southern California violently for 10 seconds in what experts later determined was a 6.0-magnitude earthquake. This time, Granada Hills did not fare as well. At the intersection of Rinaldi Street and Balboa Boulevard, gas and water mains broke, producing one of the more memorable images of that terrible day (above). With daylight, the extent of damage at the intersection (below), throughout Granada Hills, and the rest of Southern California became clear. (Both courtesy Melinda Brown Biderman.)

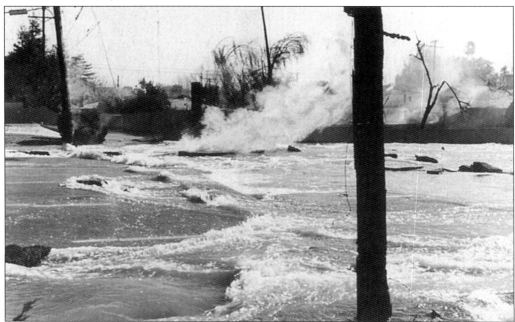

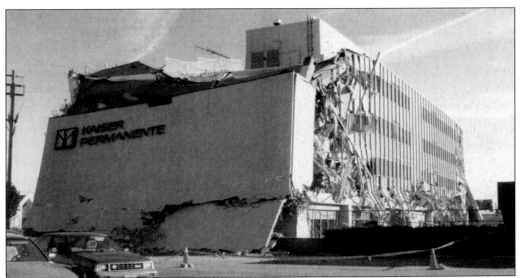

Homes and apartments throughout Granada Hills, many that had ridden through the 1971 earthquake, were knocked from their foundations or sustained heavy damage. The Kaiser Permanente building (above) on Balboa Boulevard, next to Granada Hills Community Hospital, was severely damaged. The Granada Hills Public Library again sustained considerable damage (below), as did local schools and businesses. The ground beneath Van Gogh Elementary "liquefied," rendering the school a total loss. (Van Gogh was the only school in the Los Angeles Unified School District to be destroyed in the earthquake.) The signature three-story "A" building of John F. Kennedy High School was damaged beyond repair. The bell tower at St. John Baptist de la Salle toppled. Buildings rendered structurally unsafe were "red tagged" and eventually torn down. (Above, courtesy Kim (Bruce) Radosevich; below, courtesy Granada Hills Branch, Los Angeles Public Library.)

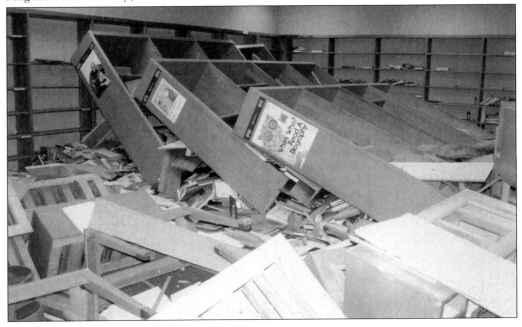

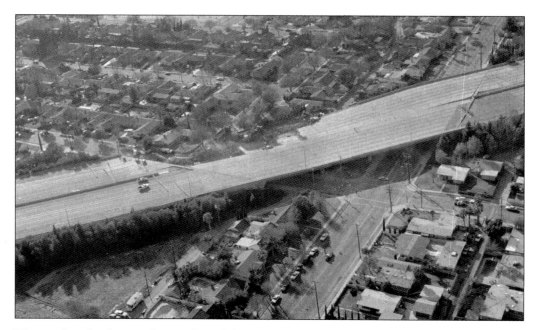

The earthquake destroyed a number of the vital freeway arteries used by commuters every day. In Granada Hills, a section of the once controversial Simi Valley Freeway (SR-118) collapsed where the freeway passes over Gothic Avenue, just south of San Fernando Mission Boulevard. Above, the full extent of the damaged area can be seen. The section collapse produced another memorable image from that day (below)—an overturned car at the breach of the collapse. (The driver of this vehicle is said to have survived.) (Above, Copyright © 1994 California Department of Transportation; below, courtesy Melinda Brown Biderman.)

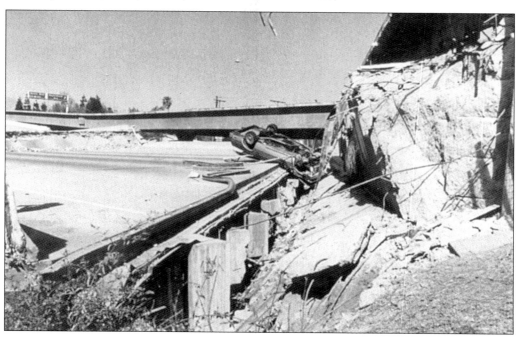

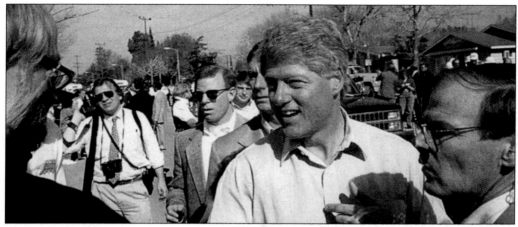

Two days after the earthquake on January 19, 1994, Pres. William Jefferson Clinton flew to Southern California to view the damage firsthand. During his inspection, President Clinton visited Granada Hills, the first time a sitting American president had come to the community. Here Clinton greets residents near the Rinaldi Street and Balboa Boulevard intersection. The Northridge earthquake made headlines around the world, and one of the images used to illustrate the damage was from Granada Hills. Below is a copy of Saudi Arabia's English language *Arab News*. The cover photograph for the earthquake story is the overturned car on the 118 Freeway, though the caption mistakenly identifies the area as Reseda. (Above, courtesy Melinda Brown Biderman; below, courtesy author.)

Again, as they did after the Sylmar earthquake, residents of Granada Hills soon began the task of tearing down, cleaning up, and rebuilding. Above, workers remove parts of the damaged bell tower at St. John Baptist de la Salle. In August 1994, a wrecking ball was brought in to take down Kennedy High's "A" building (below). Through the days, weeks, and months that followed the Northridge earthquake, neighbors stood ready and willing to help one another, proving once again why Granada Hills is "The Valley's Most Neighborly Town." (Above, courtesy Geraldine McGrath; below, photograph by Ed Hier, courtesy author.)

Seven

BUILDING FOR TOMORROW, HONORING THE PAST
1995–2006

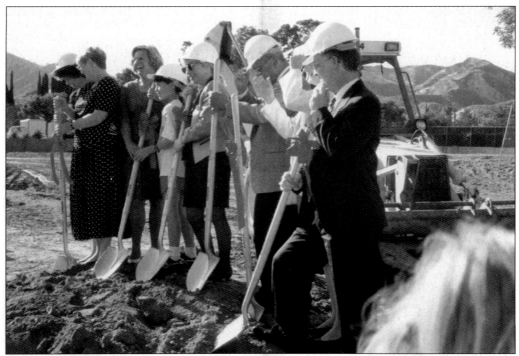

In the months and years that followed the Northridge earthquake, Granada Hills began to rebuild. Homes and businesses were repaired or reconstructed. Van Gogh Elementary, which had been destroyed, was rebuilt and welcomed students back in 1997. Here is the 1994 ground-breaking ceremony for the new Van Gogh Elementary School. Kennedy High's "A" building was replaced, this time with a two-story structure, and reopened in 1998. The Simi Valley Freeway was repaired in record time. With rebuilding came other positive and exciting changes and improvements to the community as it approached the new millennium. (Courtesy Van Gogh Elementary.)

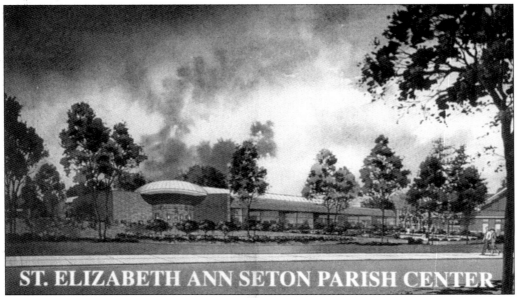

ST. ELIZABETH ANN SETON PARISH CENTER

Churches, such as St. John Baptist de la Salle, began to view the earthquake as a "blessing," allowing them to rebuild with facilities better than what was lost. This includes de la Salle's beautiful St. Elizabeth Ann Seton Parish Center, which opened in 1998. (Courtesy St. John Baptist de la Salle Catholic Church.)

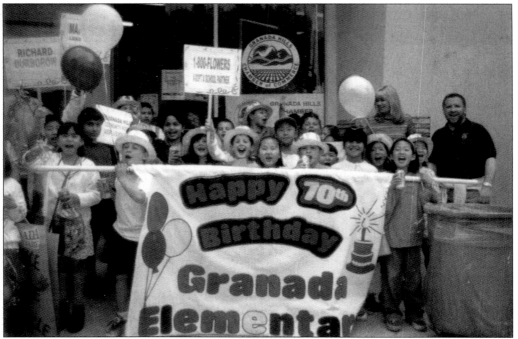

Granada Hills' schools continue their long tradition of serving the community. In 1998, Granada Elementary celebrated its 70th anniversary. Granada Hills High School converted to a charter high school in 2003 and immediately became the nation's largest such school. (Courtesy Granada Elementary.)

In 1998, the football stadium at Granada Hills High School was renamed John Elway Stadium to honor one of the school's most famous alums, who graduated from Granada High in 1979. Elway, the professional football Hall of Fame quarterback who led the Denver Broncos to two Super Bowl victories, is seen here speaking at the dedication. The stadium was rededicated in 2005 following extensive improvements to the facility. (Courtesy Chris Davis and Rick Charls.)

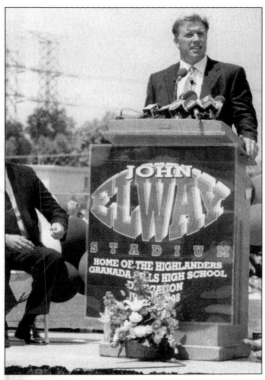

In 2005, the American Youth Soccer Organization inducted Joe Karbus into its Hall of Fame. Joe was honored as the "father" of girls' soccer due to his efforts in the early 1970s to organize the first all-girls soccer league. As of this writing, there is an effort under way to have Petit Park declared the "Birthplace of Girl's Soccer." (Courtesy American Youth Soccer Organization.)

On August 10, 1999, Granada Hills again made national headlines when a gunman, Buford Furrow Jr., entered the North Valley Jewish Community Center at 16601 Rinaldi Street and fired at least 70 shots in the facility, wounding five people—three children, a teenage counselor, and an office worker. Furrow fled the center and later murdered Joseph Ileto, a U.S. postal carrier in Chatsworth. (Photograph by Peter Genovese.)

On June 7, 2004, residents of Granada Hills became part of the national mourning for former president Ronald Reagan, as the funeral procession made its way to the Reagan Presidential Library in Simi Valley via the Ronald Reagan Freeway (formerly the Simi Valley Freeway). Residents lined the freeway overpasses and watched silently as the former president left the San Fernando Valley for the last time. (Courtesy Sharon Klek.)

Starting in 2001, groups such as the Old Granada Hills Residents Group (OGHRG officers are pictured here), the Granada Hills South Neighborhood Council, and the Granada Hills North Neighborhood Council were formed to focus attention on issues such as community livability, the possible dangers posed by the Sunshine Canyon Landfill, and preservation of Granada Hills' history. (Courtesy Jim Summers.)

The Granada Hills History Project began in 2006, originally to gather images for this book. Over the years, archives held by groups such as the chamber, local schools, and churches have been lost or destroyed. Similarly, families have discarded old photographs and ephemera, not imagining there would be an interest in the material. Even after the publication of this book, the effort to preserve Granada Hills' past will continue. Please visit www.GranadaHillsHistory.com for more information on how to help with the ongoing effort to preserve the history of Granada Hills. (Courtesy Granada Hills History Project.)

Across America, People are Discovering Something Wonderful. Their Heritage.

Arcadia Publishing is the leading local history publisher in the United States. With more than 3,000 titles in print and hundreds of new titles released every year, Arcadia has extensive specialized experience chronicling the history of communities and celebrating America's hidden stories, bringing to life the people, places, and events from the past. To discover the history of other communities across the nation, please visit:

www.arcadiapublishing.com

Customized search tools allow you to find regional history books about the town where you grew up, the cities where your friends and family live, the town where your parents met, or even that retirement spot you've been dreaming about.